THE
INVENTIONS OF
LEONARDO
DA VINCI

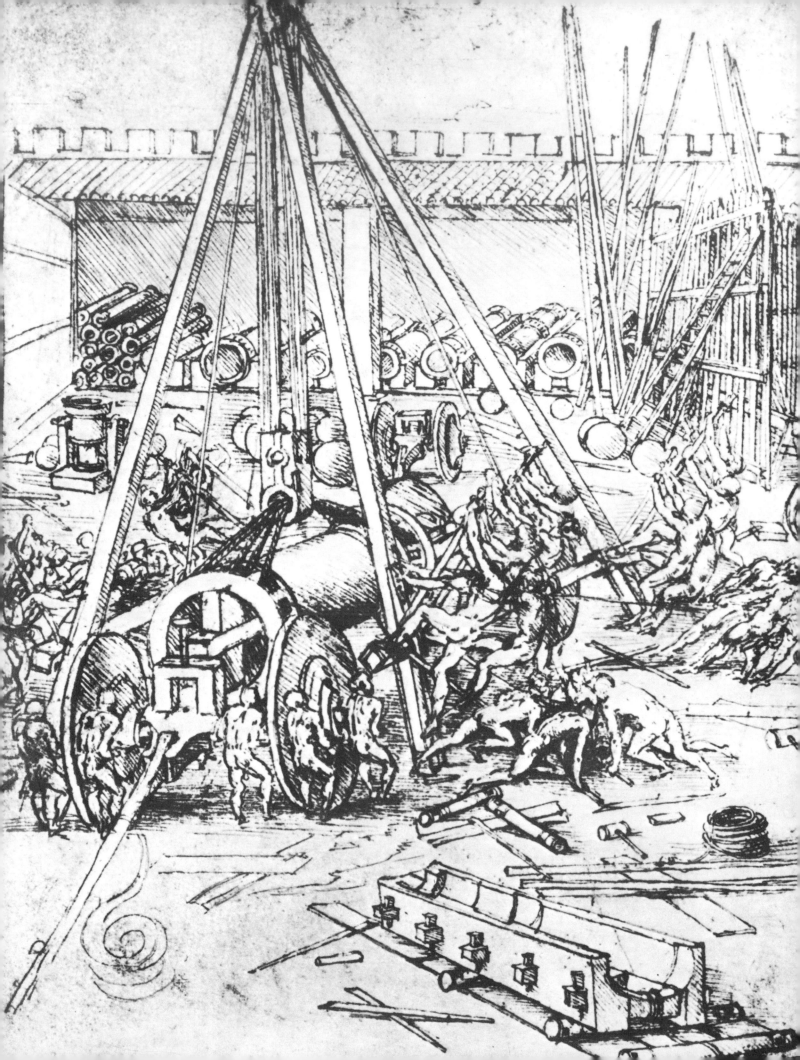

THE INVENTIONS OF LEONARDO DA VINCI

Charles Gibbs-Smith

First Lindbergh Professor of Aerospace History,
National Air and Space Museum (Smithsonian Institution)

and Gareth Rees, M.A.

PEERAGE BOOKS

ACKNOWLEDGEMENTS

The publishers would like to extend their thanks to International Business Machines Corporation for the loan of photographs of their models.

First published in Great Britain in
1978 by Phaidon Press Ltd

This edition published in 1985 by
Peerage Books
59 Grosvenor Street
London W1

© 1978 Phaidon Press Ltd

ISBN 0 907408 99 0

Printed in Hong Kong

CONTENTS

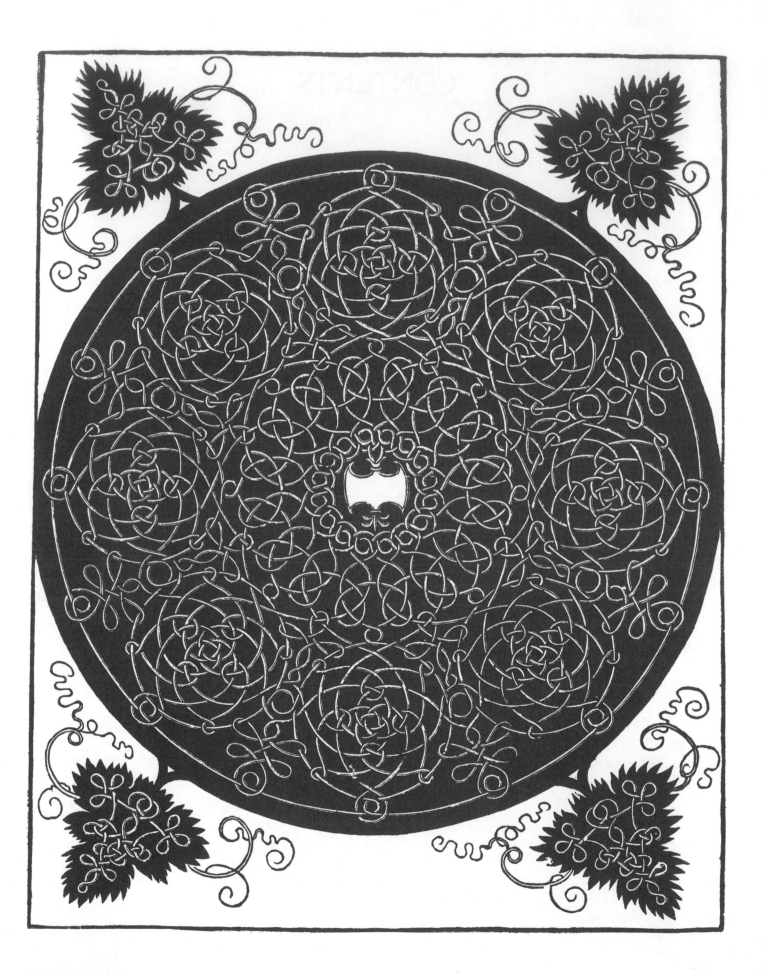

INTRODUCTION

By any standards, Leonardo da Vinci (1452–1519) is one of the greatest men in western civilization. There was not only his many-sided life – artist, architect, musician, scientist, geologist, physicist, designer, mechanic, and inventor – but the quality of his vision and the calibre of his mind: as no man before or since he comprehended the twin-worlds of science and art, and his mind embraced and illuminated everything he encountered, from paddle-boats to aeroplanes.

Leonardo was the illegitimate son of a Florentine lawyer. He was born in the village of Vinci – from which the family took its name – near Empoli, which was controlled by the Florentines. Showing his talent for drawing at an early age, Leonardo was apprenticed to Andrea del Verrocchio, a famous artist and goldsmith who practised both sculpture and painting, and in whose workshop Leonardo would have first learned how to cast bronze – technological knowledge that was crucially important for any would-be inventor of ordnance. Leonardo stayed with his master from about 1470 until 1477 or a little later, as he was given important independent commissions in 1478 and 1481: he was also under the patronage of Duke Lorenzo 'the Magnificent' until 1482.

Within a year or two Leonardo had travelled north to Milan, where he was employed by Duke Ludovico Sforza, who allowed his scientific and technological genius to grow and blossom. Here is the famous draft of the letter Leonardo wrote to Duke Ludovico (Il Moro) of Milan (Richter's translation) asking for employment:

'Most illustrious Lord, having now sufficiently considered the specimens of all those who proclaim themselves skilled contrivers of instruments of war and that the invention and operation of the said instruments are nothing different from those in common use: I shall endeavour, without prejudice to anyone else, to explain myself to your Excellency, showing your Lordship my secrets, and then offering them to your best pleasure and approbation to work with effect at opportune moments on all those things which, in part, shall be briefly noted below.

(1) I have a sort of extremely light and strong bridges, adapted to be most easily carried, and with them you may pursue, and at any time flee from the enemy; and others, secure and indestructible by fire and battle, easy and convenient to lift and place. Also methods of burning and destroying those of the enemy.

(2) I know how, when a place is besieged, to take the water out of the trenches, and make endless variety of bridges, and covered ways and ladders, and other machines pertaining to such expeditions.

(3) Item. If, by reason of the height of the banks or the strength of the place and its position, it is impossible, when besieging a place, to avail oneself of the plan of bombardment, I have methods for destroying every rock or other fortress, even if it were founded on a rock, etc.

(4) Again, I have kinds of mortars; most convenient and easy to carry; and with these I can fling small stones almost resembling a storm; and with the smoke of these cause great terror to the enemy, to his great detriment and confusion.

(5) And if the fight should be at sea I have kinds of many machines most efficient for offence and defence; and vessels which will resist the attack of the largest guns and powder and fumes.

(6) Item. I have means by secret and tortuous mines and ways, made without noise, to

reach a designated (spot), even if it were needed to pass under a trench or a river.

(7) Item. I will make covered chariots, safe and unattackable, which, entering among the enemy with their artillery, there is no body of men so great but they would break them. And behind these, infantry could follow quite unhurt, without any hindrance.

(8) Item. In case of need I will make big guns, mortars and light ordnance of fine and useful forms, out of the common type.

(9) Where the operation of bombardment might fail, I would contrive catapults, mangonels, trabocchi, and other machines of marvellous efficacy and not in common use. And in short, according to the variety of cases, I can contrive various and endless means of offence and defence.

(10) In time of peace I believe I can give perfect satisfaction and to the equal of any other in architecture and the composition of buildings public and private; and in guiding water from one place to another.

Item. I can carry out sculpture in marble, bronze or clay, and also I can do in painting whatever may be done, as well as any other, be he who he may.

Again, the bronze horse may be taken in hand which is to be to the immortal glory and eternal honour of the prince your father of happy memory, and of the illustrious house of Sforza.

And if any of the above-named things seem to any one to be impossible or not feasible, I am most ready to make the experiment in your park, or in whatever place may please your Excellency – to whom I commend myself with the utmost humility, etc.'

This letter may seem conceited, even bombastic to modern readers; but it was neither in terms of the time. Leonardo stated quite literally what he was able and prepared to do. We do not know how much of it he was called upon to perform; but he stayed in Sforza service from 1483 to 1499, and it is to this period we owe so many of his surviving sketches for the various arts and technologies.

In 1500 Leonardo went to Venice, and in 1502 he went to work for Cesare Borgia, Duke of Valentinois, as architect and general engineer, travelling with his master for much of the time. It was during this period that he started to work as a cartographer, compiling both town and country maps, the most famous of which is his drawing of Imola.

But he was back in Florence during March of 1503

and stayed there until 1506, again employed as a military engineer. During this time he planned to make Florence navigable to the sea by building a canal and worked on fortifying Piombino. In May 1507 Louis XII of France, who had conquered Milan, employed Leonardo. In 1513 he left for Rome, but after meeting François I, who had succeeded Louis XII, and – now a venerable and aged man – went in 1515 to live in comfort and glory at the Castle of Cloux, near Amboise, in France. Here he died on 2 May 1519.

It may seem strange to us nowadays that Leonardo moved from one employer to another so frequently. From 1490 to 1507 he served five different masters as a military engineer, travelling from Florence to Milan, back to Florence and then to Venice, Piombino, Imola and Pisa, before returning to Florence and Milan prior to his final journey to France. Part of the reason for this incessant journeying was that this was a time of war in Central Italy, and sculptors and architects were much in demand, not so much for their artistic skill as for their knowledge of engineering. It is no accident that in his letter of commendation to Ludovico Sforza Leonardo lists 31 claims of a technical nature and only six to do with the arts of painting, sculpture and architecture. As a servant of a head of state he could best serve as a practical engineer rather than an artist.

As a scientist Leonardo's ideas are quite unique in their audacity and imagination, and his ideas for new weaponry and uses of machines are the most fascinating. His unrestrained curiosity led him to many strange conclusions and extraordinary inventions.

Leonardo's drawings of new and terrifying weapons of war best reveal his own extraordinary inventiveness and reflect the age in which he lived – a time of transition from crossbowmen and mounted troops to fusiliers and cannoneers. His investigations are breathtaking in their scope – ideas for cannonballs filled with shrapnel, rockets, ballistic missiles, breech-loading cannons, multiple fire, steam cannons and multi-barrelled cannons, numerous catapults, wall-scaling devices and pontoon bridges. His imagination ran riot, hundreds of ideas were sketched out, discarded and then rethought. Often the designs were totally unworkable but this did not deter him. The driving force of his imagination was motivation enough, and ideas that must have appeared quite fantastic to his contemporaries had to wait for recent technological advances to make them practical.

Leonardo's imagination took flight also in his designs for gadgets for all kinds of jobs. His underlying preoccupation was with the need to design machines which would speed up and simplify day-to-

day mundane tasks. And to do this he used sequential action, that is he tried to design automatic machines. In this he was the very epitome of modern man with his interest in labour-saving devices and concern with increased efficiency. We can only speculate on why Leonardo placed such emphasis on labour-saving machinery – he lived neither in a slave society where there is no incentive for such machinery, apart from gadgetry, owing to the cheapness and abundance of labour, nor in an industrialized society where small differences in the cost-effectiveness of techniques can make the difference between profit and bankruptcy.

Unlike modern industrial man Leonardo was constantly bedevilled by the lack of a prime mover, such as gas, electricity or the internal combustion engine. This led him again and again to investigate ways of converting reciprocating motion to rotary motion, a basic need for all machinery. To achieve this he experimented with ratchets, gears, cams, pulleys, cranks and linkages, and racks and pinions; and he harnessed wind power and muscle power and power in springs and flywheels.

In other fields, too, Leonardo was amazingly active. He studied cartography, anatomy, geometry, horology (including clocks with pendulums) and music (sketches include a bell with two hammers and multiple dampers, a three-tone bagpipe and a portable organ). He worked out what was to become the basic theorem of hydrodynamics – in *Codex Madrid I* he noted that energy was a function of position and motion, thus differentiating potential from kinetic energy. He also worked on stress distribution, especially in arch construction. In almost every area of study his penetrating intelligence threw up new ideas and his artistic skill illustrated them.

Leonardo's mentality and character had a great influence on his output. He had the greatest difficulty in bringing himself to finish any painting, which is the reason why his attributed pictures scarcely exceed a dozen. He was, however, completely at home in his notebooks and on scraps of paper, where his brilliant mind and hand dashed off ideas by the hundred, and often led him to do the most careful drawings of some of his concepts and observations. On these pieces of paper, he felt no constraint to be as careful an artist as in his commissioned paintings: with a pencil or chalk in his hand he felt he could be the most meticulous draughtsman or the most perfunctory of sketchers, according to his whim or his strong will, or whether his subjects were humans or machines.

Leonardo has been credited with the invention – the first and original invention – of many items of science and technology. In fact, although he did originate a number of inventions, it has now been shown that many of his designs are rather improvements or extensions of inventions already existing before he started work on them. Some of his ideas are brilliant in their conception and some are brilliant in the way he thought an invention 'through'; and often he shows two or three different aspects of some problem that took his fancy.

Unfortunately his work in aviation is perhaps the least valuable – although here too are some remarkable 'previsions' so to speak – because, unlike his other more matter-of-fact work, aviation was as much a symbol of freedom and release for the human spirit as it was a technically thought-out series of ideas: some of his machines are feasible, a few of them possible, but many of them quite fantastic and outside all realms of possibility. But this is the small penalty which must be paid for sheer brilliance of conception and execution in other fields. Not many of Leonardo's ideas seem to have been realized in 'hardware' and utilized; most show him thinking and exploring with his mind and hand; and occasionally almost 'doodling', except that even his doodles often have technical talent of the highest order.

It was Leonardo's custom to fill the pages of his notebooks with drawings for ideas as they occurred to him. Thus notes on painting or rent owed can be found next to drawings of war machines or plants or geometrical figures. Again and again we see him thinking on paper, testing out various ideas as they occurred to him. As an artist he was capable of illustrating in pencil far more clearly than with words his ideas, designs, principles and applications. This artistic ability, allied to a modern concern with details of machinery, makes his work highly reminiscent of twentieth-century technical drawing. Indeed, not until Diderot's *Encyclopédie* in the eighteenth century did technical drawing become as clear and instructive.

As many readers will know, Leonardo wrote in 'mirror-writing', that is to say he started on the right and wrote leftwards across the page. This strange phenomenon used to be described as a device for preventing his students and others from reading his thoughts. This is, of course, quite ridiculous, because all you had to do was to put a mirror in front of his handwriting, and read it off as easily as if he had written normally. No wholly convincing reason has been advanced for this backward-reading script, but the medical experts tend to believe that Leonardo was born right-handed and normal, but that at an early age, he injured his right hand and started to use his left. Unless checked at an early age, the instinct of many children thus injured would be to write with their left hand, from right to left; and this is considered what most probably happened to Leonardo.

Sadly, only a very small percentage of Leonardo's writings have survived, and those notebooks that have come down to us have been rearranged and muddled, pages have been torn out and lost. Of the notes that have survived the largest collection is the *Codex Atlanticus* in the Ambrosiana Library, Milan. The Trivulziana Library in the same city also has a collection. The Royal Library in Turin houses the small codex (manuscript volume) on the flight of birds. In England, apart from the large number of drawings at Windsor Castle, there are the *Codex Leicester, Codex Arundel* (British Museum) and the three Forster codices (Victoria and Albert Museum). In Paris the French hold twelve manuscripts, lettered A, B, C, D, E, F, G, H, I, K, L, M. Finally, in Madrid, are the most recently discovered manuscripts, *Codex Madrid I* and *Codex Madrid II*.

When Leonardo died on 2 May 1519 in France, the faithful companion and friend who was with him was Francesco Melzi. Shortly before his death, Leonardo made a will in which he left the entire corpus of his manuscripts to Melzi. Never was there a more charming and human gesture; but never was there a more ultimately disastrous gesture.

Melzi returned with this fabulous hoard of material to his villa at Vaprio (between Milan and Bergamo): here he guarded his treasure affectionately and jealously, and resisted all offers to part with it, for over fifty years. But history can only produce the severest censure upon Melzi, kind and loyal man though he was. For he made no effort to ensure that Leonardo's manuscripts were left in reliable hands after his death. Melzi well knew that his son Orazio had not the slightest interest in the arts and sciences; yet he deliberately left all the manuscripts in his will to this deplorable man. Orazio Melzi 'could not have cared less' (in modern phrase) what happened to this priceless collection of documents, and he allowed various people who appeared on the scene to beg, borrow, and all but steal, anything they wanted. Orazio permitted the dispersal of the Leonardo manuscripts, a dispersal which led to damage, loss and vandalism, although happily the bulk of the material has survived, thanks to the care of many devoted men over the centuries. Thus at Orazio's door lies the immediate blame but it is at the door of old Francesco Melzi that the real blame must lie, for it was he who betrayed the deep trust Leonardo placed in him by allowing this massive evidence of his genius to fall into the hands of an unworthy son.

All in all, Leonardo was an intellectual and artistic giant, whose like has never appeared either before or after him; he stands unique in history, and once 'bitten' by his genius, many men and women have spent years of their lives studying the paintings, drawings, sketches and doodles of this extraordinary human being, and the more one searches among the many thousands of his drawings, the more one marvels that the mysteries of human creation should have been combined to produce at this particular time this solitary colossus among mortals.

This short book is primarily intended to whet the reader's appetite rather than convey detailed information, and the illustrations have been chosen to show the extraordinary variety of subjects Leonardo's mind examined. The reader is asked to multiply the various machines and ideas by about ten, to get an idea of the fertility of this Renaissance giant.

Aeronautics

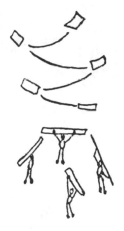

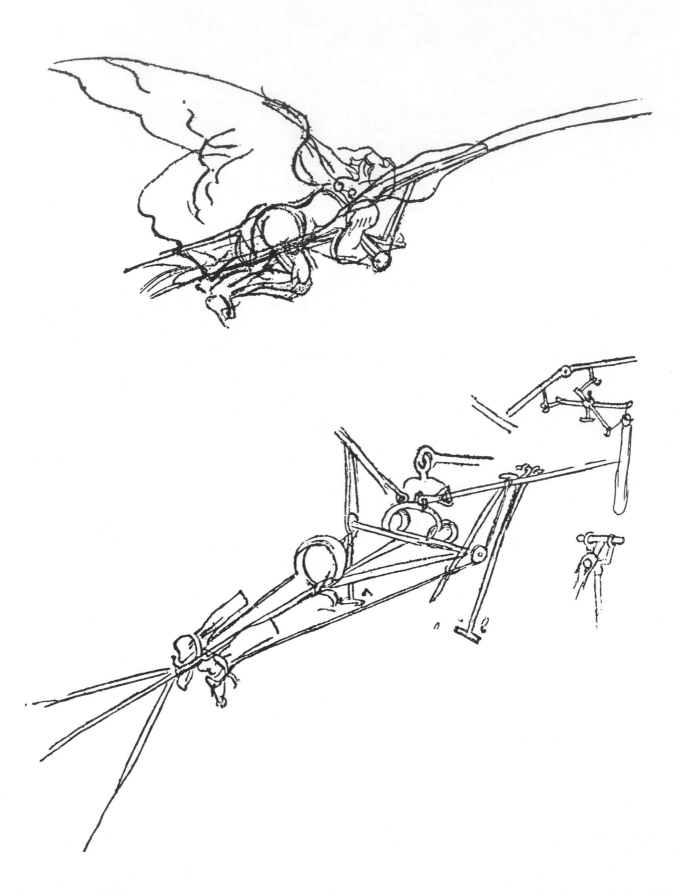

1. OPPOSITE ABOVE *Prone ornithopter, with pilot's legs moving together, and wings hand-operated on the upstroke:* c. *1487*

OPPOSITE BELOW *Prone ornithopter, sketched as in flight:* c. *1487*

ABOVE. *Model of ornithopter in flight*

Most of Leonardo's investigations into the problems of flight were, sadly, based on the misconception that man had sufficient muscle power to emulate the birds. Leonardo also mistakenly thought birds flew by beating their wings downwards and backwards; in fact, on the downstroke, the wing-feathers twist into miniature propellers to give thrust, with the inner wing providing lift. Consequently he experimented ceaselessly with an unworkable notion: flapping-wing aircraft (ornithopters). Only towards old age did he envisage a more rational approach,

incorporating fixed-wing structures.

In these drawings, one of his earliest designs, the pilot lies on a frame with his feet in stirrups. By moving his feet together the pilot gives a downstroke to the wings. The upstroke is made by the hands operating a lever, one of which is clearly seen hanging down on the right. For the upstroke, Leonardo also suggested using a spring or pulling up both feet simultaneously.

Also illustrated is a model of Leonardo's ornithopter.

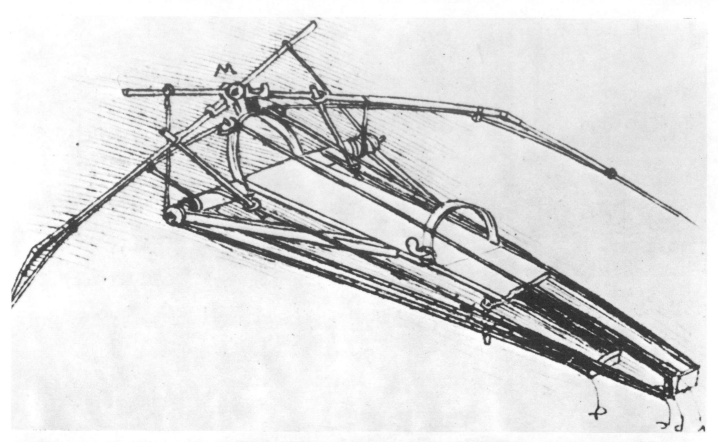

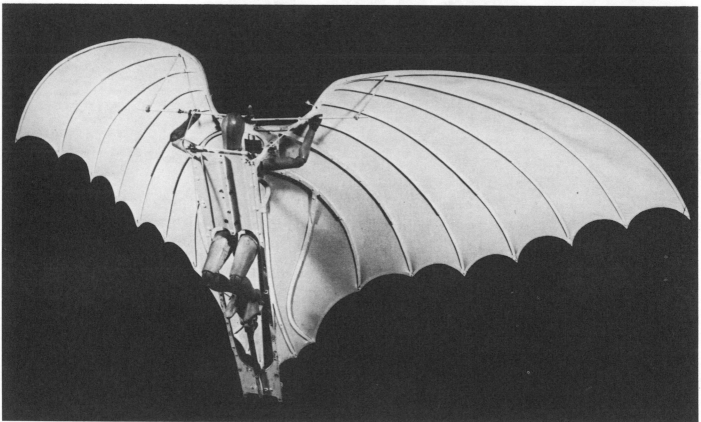

2. TOP *Prone ornithopter*, C. *1486–90*

ABOVE *Model of prone ornithopter*

In this design the pilot's legs are alternately moved up and down to raise and lower the wings. The model shown here includes a windlass worked by the pilot's hands and arms to help beat the wings.

3. BELOW *Prone ornithopter, with a head-harness to operate the elevator-cum-rudder: 1486–90*

RIGHT *Close-up of the head-harness*

This is by far the most remarkable of Leonardo's prone designs. The machine is equipped with a sophisticated type of flight-control – the first in history – by means of a head-harness operating a cruciform elevator-cum-rudder: this is shown twice, once in place on the aircraft where the device is seen out to the right, impinging on the edge of the paper (with its head-harness out in front); and again, attached to the pilot's head, in a separate drawing in the top right corner (illustrated separately here).

This cruciform control-unit was not to be re-introduced until Sir George Cayley used it in 1799. What is so strange is that in no other surviving drawings by Leonardo does this device appear again. This machine has the added interest of the two hand-operated cranks below the supporting frame, to assist in the down-beat of the wings.

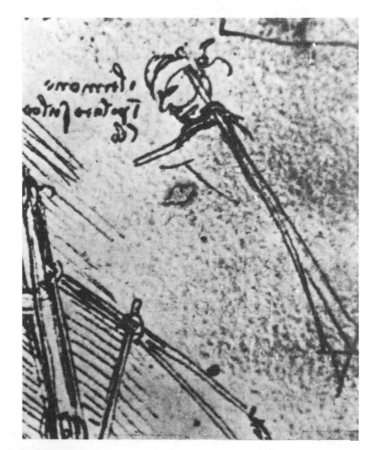

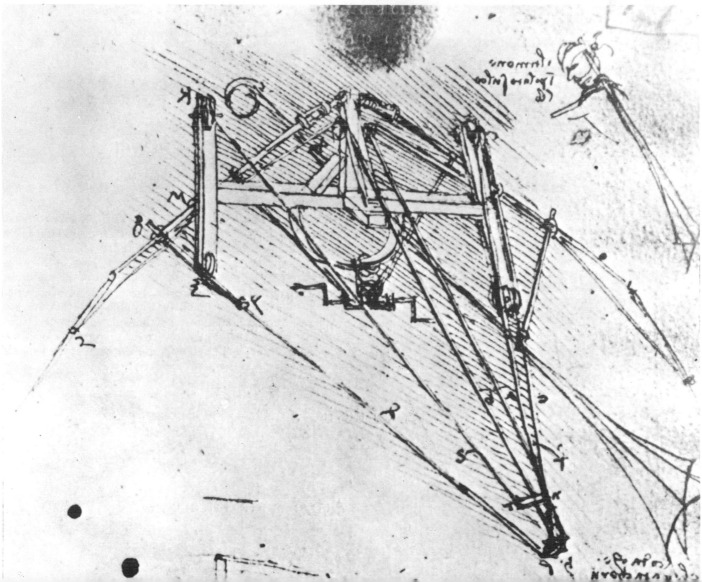

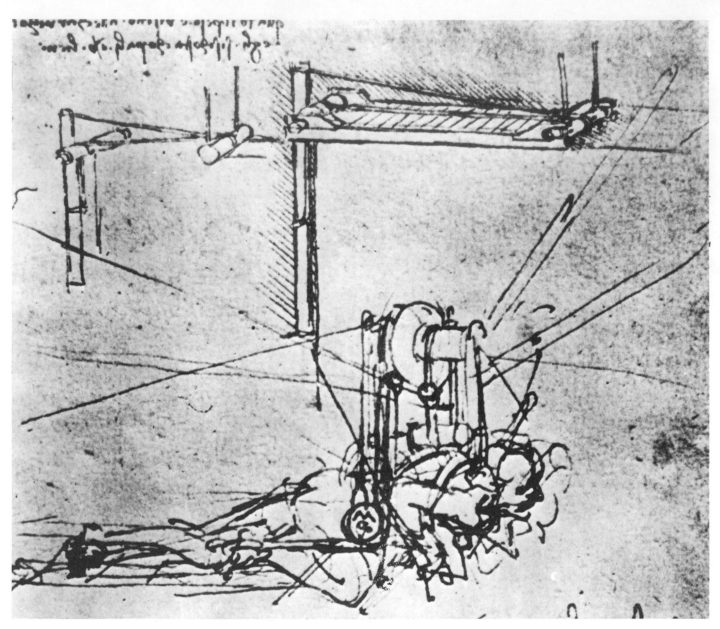

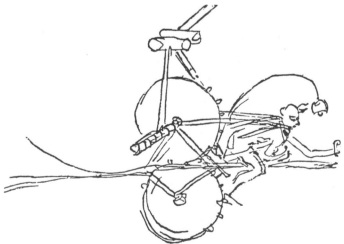

4. *Prone ornithopter, with alternate action of the legs, and four wings: 1486–90*

This rough but vivid sketch is of an ingenious machine with four wings, which beat with one up and one down on either side. Leonardo uses here one of his favourite transmission systems, with cables running over drums: in this case, two of the wing-spars are attached to a large rotating disc, aft of the top drum, which are caused to rock from side to side, with one wing beaten down while the other is simultaneously pulled up: the other pair of wings rock on fulcrums, and the ends of their levers are attached by joints to the cables which run up vertically to operate the upper drum and disc, thus producing beats of the wings in opposite directions to those rocking with the disc.

5. *Semi-prone ornithopter, showing gear train, and cog-pedal transmission: c. 1485*

In this wonderfully wild little sketch, the pilot, oddly reminiscent of a racing cyclist, operates a gear-train transmission by pedalling directly on the cogs of the lower wheel, while simultaneously seeming to operate hand levers as well.

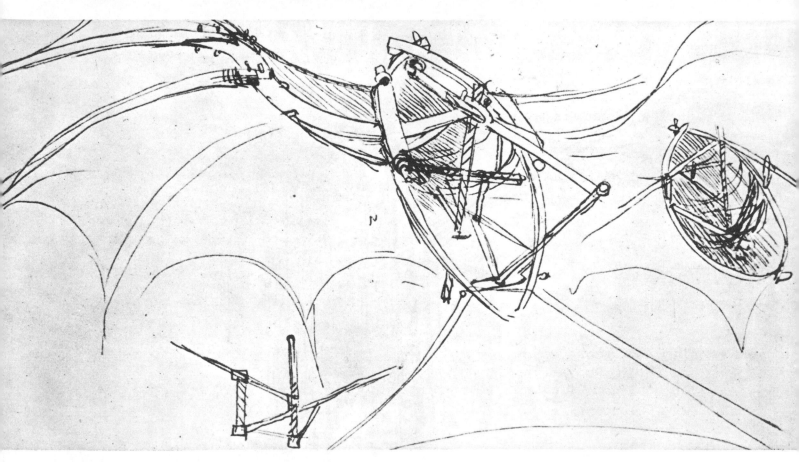

6. ABOVE *Boat-shaped ornithopter:* C. *1487*

An ornithopter with a boat-shaped fuselage or 'car', of which there are only two fairly explicit illustrations. The other drawing (not illustrated) clearly implies a similar car, but with a different transmission system. Leonardo has now arrived at the concept of a vehicle in which the pilot sits or stands, and in which he is at one remove, so to speak, from the actual power transmission. Here the pilot operates the wings via a quick-thread jack, with a fulcrum in the form of a roller fixed to each gunwale of the car, under which the rowing-spars pass. It is somewhat hard to see how Leonardo here intends to effect the thrust component of the wings. But he must have known that no device such as he here suggests could possibly beat the wings fast enough for sustentation and propulsion. A notable feature of this design, by the way, is the properly large spreading tailplane (cum-elevator?) which is closely similar to that suggested by Henson in 1843.

7. BELOW *Boat-shaped ornithopter, with crank and pulley transmission:* C. *1487*

This machine, which also clearly implies a pilot in a 'car', shows one of Leonardo's favourite transmission devices, with cranks operating rollers, over which the cables pass to the wings. There is also here no hint of wing-twisting to effect the thrust component. This design was, I feel, just a general idea thrown off without any intention to work out complete propulsion systems.

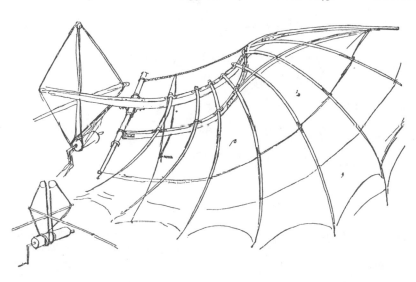

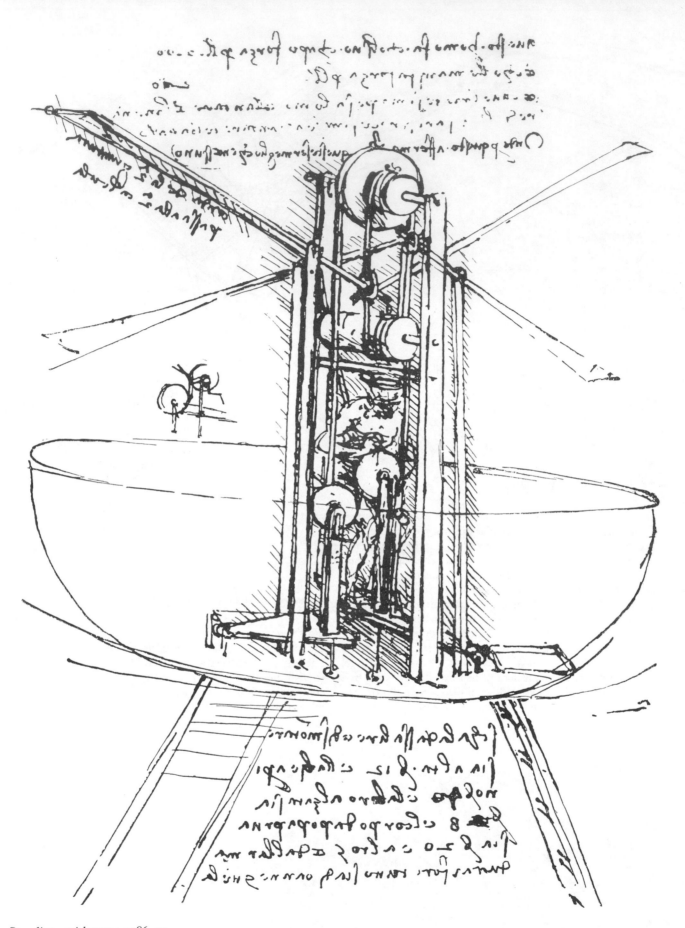

8. *Standing ornithopter: 1486–90*

This is Leonardo's most outrageous conception of flight: a man standing in a bowl-shaped aircraft operates four beating wings *via* a massive transmission of hand-and-foot operated drums, treadles and the like, at whose weight the aerodynamicist's mind could only boggle. His obsessional pursuit of ingenuity is now in full flood.

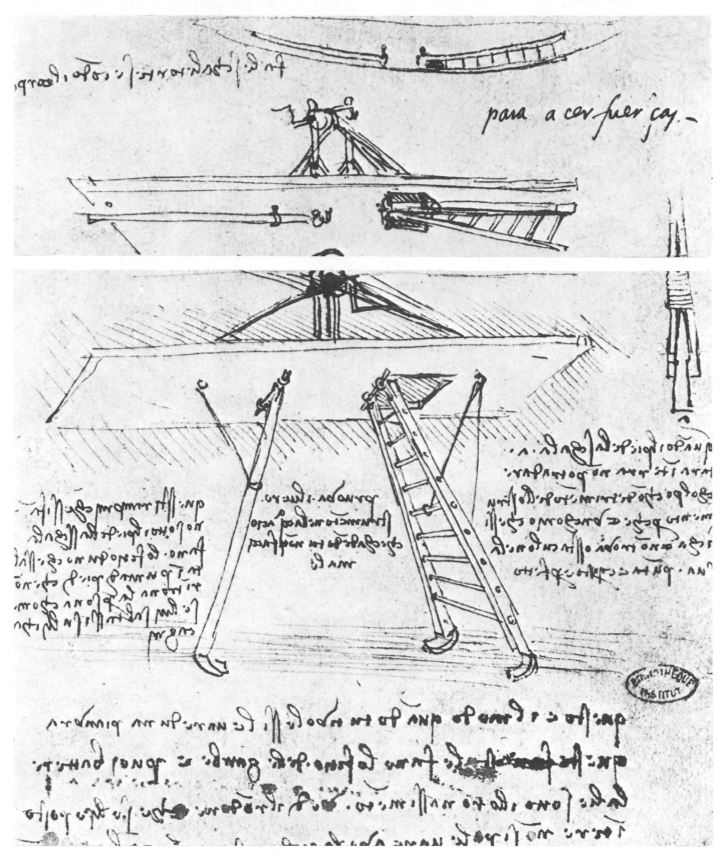

9. TOP. *Retracted undercarriage of standing ornithopter*

ABOVE *Undercarriage mechanism of standing ornithopter: 1486–90*

Leonardo's ingenuity in ornithopter design even extends to devices such as a retractable undercarriage and an entry ladder. These additions would, of course, have sent up the weight even further, especially as a separate windlass is provided to effect the retraction. It is interesting to note that in the topmost sketch, Leonardo has shown how the leg and ladder, which constitute the undercarriage, are to be neatly tucked up within the contour of the bowl-fuselage. This is not evidence that he was particularly aware of the importance of aerial streamlining; most of his attention in this subject was paid to marine streamlining (see Fig. 69).

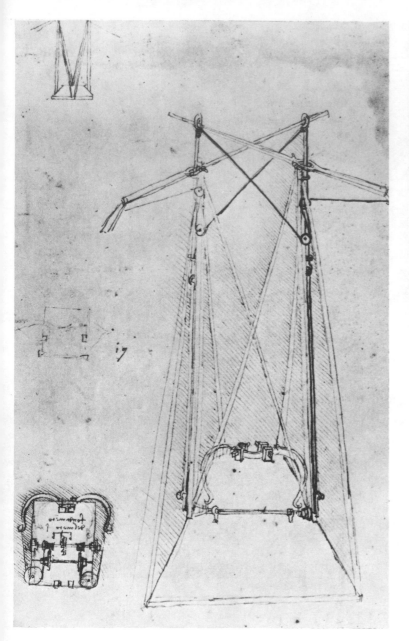

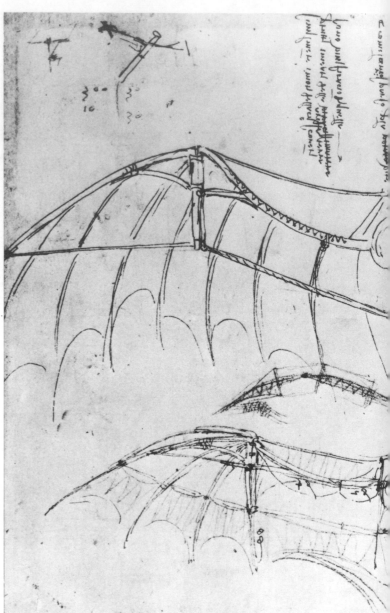

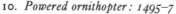

10. *Powered ornithopter: 1495–7*

Before Leonardo arrives at his last proper aircraft, which exhibits advanced characteristics, there is his only powered machine to consider. It can be dated to the years 1495–7, and indeed is only a pipedream of an aircraft; but it is an interesting dream. It shows him, in his middle forties, turning to the only source of power then available to him, the bow-string motor. This of course can be made very powerful, but it is of exceptionally short duration. The machine seems to be a standing-type ornithopter, but with only two wings. The motor, roughly indicated in the general sketch, is shown alongside, where the bow mechanism is presented in more detail, with the bow-strings operating through a gear-train. The whole conception of this machine was, of course, charmingly outrageous, and the idea of the pilot periodically having to wind up the mechanism en route, so to speak, presents an intriguing vision of desperation! But this design at least shows that Leonardo has been pondering the problem of the ornithopter, and was now thinking in terms of mechanical, rather than muscular, power.

11. ABOVE *Semi-ornithopter, with fixed inner wings, and 'hang-glider' pilot position: 1497–1500*

OPPOSITE *Otto Lilienthal flying one of his biplane-gliders: 1895*

It seems to have been after the period of the standing ornithopter – but dates can only be approximate – that the worst of Leonardo's fever of fantasy had burnt itself out: thereafter we find some of the most remarkable of his creative thinking in aviation, as opposed to his obsessional thinking. In what may be called here a semi-ornithopter, we have a prevision of Otto Lilienthal's hang-gliders of 1891–6, where the pilot hung vertically in the centre section of his machine. But Leonardo did not here intend his pilot to swing his torso and legs to shift the centre of gravity, and hence exercise a limited control of it in pitch, yaw and roll; nor did he intend to make fixed-wing glides.

The most significant feature in this type of aircraft is the abandonment of the pure ornithopter, in which the whole of each wing is flapped, and the adoption of a partially fixed-wing configuration in which only the outer portion of the wing is flapped. This was another prevision of Lilienthal, in this case of his powered glider of 1895, which incorporated multiple ornithoptering wing-tip slats, in imitation of a bird's primary feathers. In Leonardo's case, it was a question of about half the

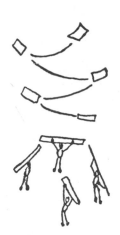

12. *Falling-leaf glider, showing a series of descent positions: 1510–15*

It is at the very end of his life that we find one of the most intriguing of Leonardo's ideas. It scarcely merits inclusion among his aircraft types; but it is the sole representative in his drawings of the pure gliding principle, however primitive. Beside the first (TOP) set of these little sketches – the aircraft consisting of a piece of slightly curved paper – Leonardo writes: 'Of the things that fall in the air from the same height [the one] that will produce less resistance [is the one] which descends by the longer route: it follows that that which descends by the shorter route will produce more resistance ... [the paper] although in itself of uniform thickness and weight, being in a slanting position, has a front that has more weight than any other part of its breadth equal to the front, which can serve as its face; and for this reason the front will become the guide of this descent.'

Then, referring to the lower series of sketches, he writes: 'this [man] will move on the right side if he bends the right arm and extends the left arm; and he will then move from right to left by changing the position of the arms.'

Here are the beginnings of controlled glider flight, written down and illustrated less than ten years before the death of this remarkable man.

wing-area being made to flap. This shows, I believe, that Leonardo had been thinking of the structure of a bird's wing, and had realized that the inner part moves far slower than the outer, and therefore produces mainly lift rather than thrust: so he wisely economizes on the amount of wing-surface that has to be flapped in relation to the muscular resources of the pilot, and thus concentrates movement and effort where they can best be utilized.

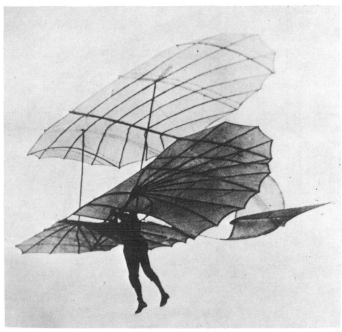

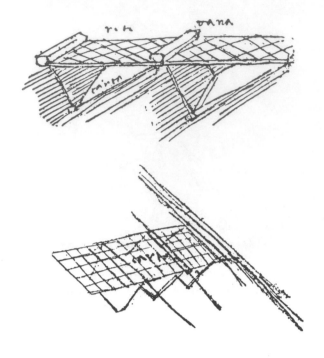

13. *Two types of flap-valves for ornithopters: 1487–90*

Leonardo had observed the way in which a bird's feathers overlap to give maximum strength, and to present an air-tight surface on the downstroke; he concluded that, on the upstroke, this overlapping structure would, so to say, lift apart, and allow the air to pass easily between the feathers to reduce resistance. In fact, this sequence of events does not take place in bird-flight, and the wing on its upstroke does not let the air through. But Leonardo's belief led him to invent a highly ingenious flap-valve device, which was to remain aeronautically unexploited until Jacob Degen arrived at the same conclusion during the first decade of the nineteenth century, and incorporated it in his ornithopter. It consisted of stretching a network between the wing-ribs above the fabric covering, so that the wing would beat 'solid' on the downstroke. On the upstroke the fabric would flap loosely downwards allowing the air to pour through the wings.

Leonardo was as much fascinated by bat-flight as by bird-flight, as will be seen in these flap-valve wings. His wing-forms in general show evidence of the influence of both. At times he specifically recommends the bat: 'remember that your bird (i.e. aircraft) should have no other model than the bat, because its membranes serve as an armour, or rather as a means of binding together the pieces of its armour, that is the framework of the wings.' But he is just as apt to return to bird construction at other times.

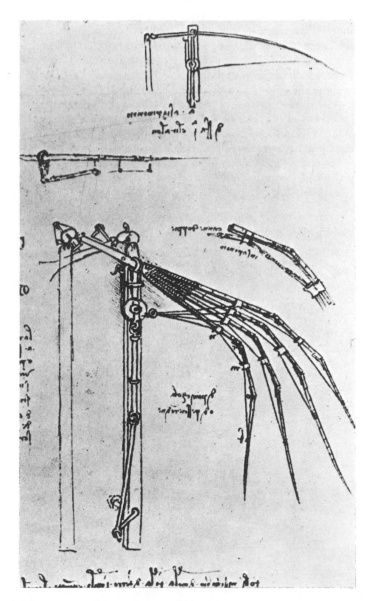

14. *Mechanism for flapping and twisting the wing of an ornithopter: 1495–7*

Leonardo, from the first, arranged for his wings to be articulated in order to produce – *via* the twisting of the spar – the downward and backward beat. As his ingenuity increasingly took hold, he indulged in ever more complex designs for the articulated 'fingers'. His drawings are often beautifully executed, and one of the best – dated 1495–7 – is shown above, where Leonardo's twisting and pulley arrangements are admirably set out. But he was soon to abandon these obsessive ingenuities, and progress to simpler and more direct methods.

15. *An ornithopter pilot controlling flight by body-movements: 1505*

Leonardo is here anticipating the flight-control technique of Lilienthal in 1891–6, in which the pilot throws his hanging torso and legs in the direction in which he wishes to travel, thus shifting the centre of gravity, and with it the centre of pressure. Leonardo here adopts the unwise technique of exerting this shift from above, and hence making for a destabilizing situation: but, if he had lived, he would almost certainly have realized this, and adopted the hang-glider technique of flight-control prior to the achievement of movable control surfaces, which he had already envisaged with his cruciform tail-unit, but unfortunately abandoned.

16. *Wing-testing rig for an ornithopter wing: 1486–90*

Leonardo has left a few sketches of devices for testing and measuring the forces acting on his ornithoptering wings, the best known being the vigorous drawing reproduced here.

This test would be somewhat misleading, since the pilot of an ornithopter has to flap two wings simultaneously, and the expenditure of a man's energy in beating down two wings would be too much in excess of double the force necessary to beat one down owing to the metabolic and energy-replacement problems involved.

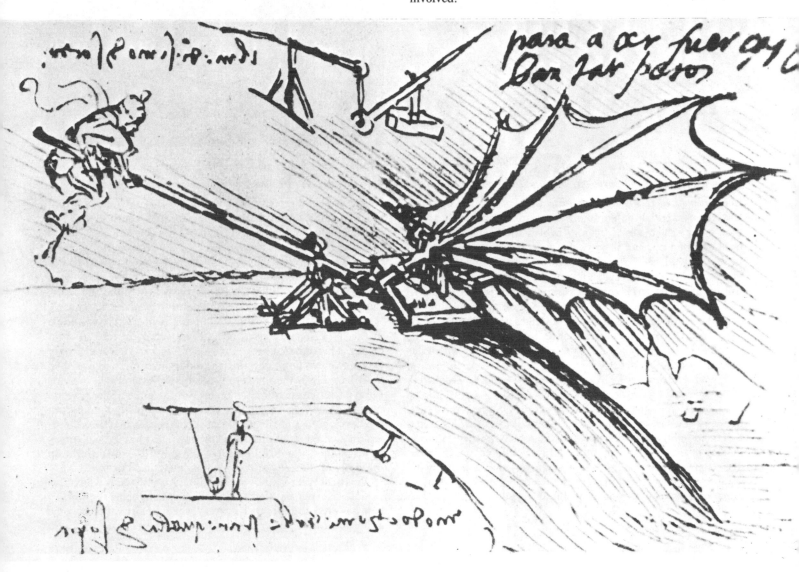

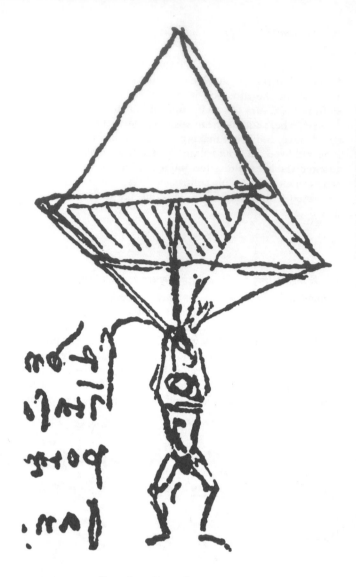

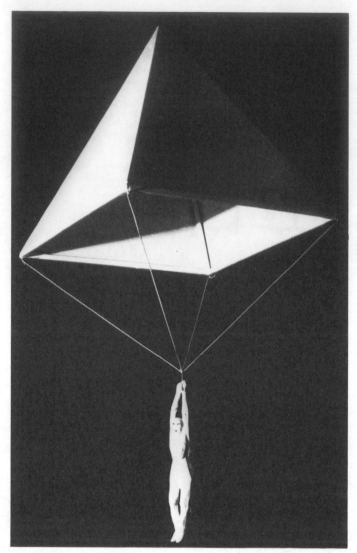

17. ABOVE LEFT *Parachute: c. 1485*

ABOVE RIGHT *Model of parachute (minus centre pole)*

Leonardo's design for a parachute is the world's best example, and is of pyramidal configuration. Leonardo wrote beside it: 'if a man had a tent made of linen, of which the apertures have all been stopped up, and it be twelve *braccia* [21 feet] across and twelve in depth, he will be able to throw himself down from any great height without sustaining any injury'. An interesting feature of the design is the pole running down from the apex of the canopy: Leonardo was concerned here with making his overall structure rigid, with the shroud lines tied to the end of the pole. As the man hangs by his arms beneath the jointure, he would not be so badly affected by the oscillations from which this type of parachute would suffer.

It would be interesting to know whether Leonardo ever had in mind the escape from aircraft, as well as the more general idea he describes, and also why he did not employ a variation on the theme of the parasol, rather than the tent. As Leonardo's sketch remained unknown until late in the nineteenth century, it played no part in the development of modern parachutes, which are all derived from the parasol, the first air-to-ground jump being made by Garnerin in 1797. Nevertheless his drawing remains remarkably similar to modern parachute design.

18. OPPOSITE TOP *Helical-screw helicopter: 1486–90.*

OPPOSITE BELOW *Passenger helicopter about to land: 1950s*

Leonardo's admirable little helicopter design, of which he seems to have made a successful model, could until recently claim to be the first helicopter of history. But it has now become known that the model helicopter was understood and successfully made before Leonardo's machine, in the form of a toy whose rotor was based on windmill sails, and which was sent spinning up into the air by pulling sharply on a cord wound tightly round the shaft; the earliest known toy of this kind dates from about 1320–5.

Leonardo's machine carried its power on board, but was made in the unsatisfactory form of a helical screw, instead of rotor blades. This design, as with the rest of Leonardo's work, did not become known until long after the model helicopter, powered by a variety of prime movers, was firmly established on the aeronautical scene. But if the report is true – and one has no good reason to doubt it – Leonardo played an indirectly vital part in the development of the modern helicopter; for it is said that it was an illustration of this model that was shown to Igor Sikorsky by his mother, and that the sight of it inspired him later to take up the study of the helicopter, in which he has led the world.

This helicopter model – if we assume it was made and flown, as I think we may – has the curious distinction of being the world's first powered aircraft; that is to say, the first aircraft to become airborne with its power-unit incorporated in its structure.

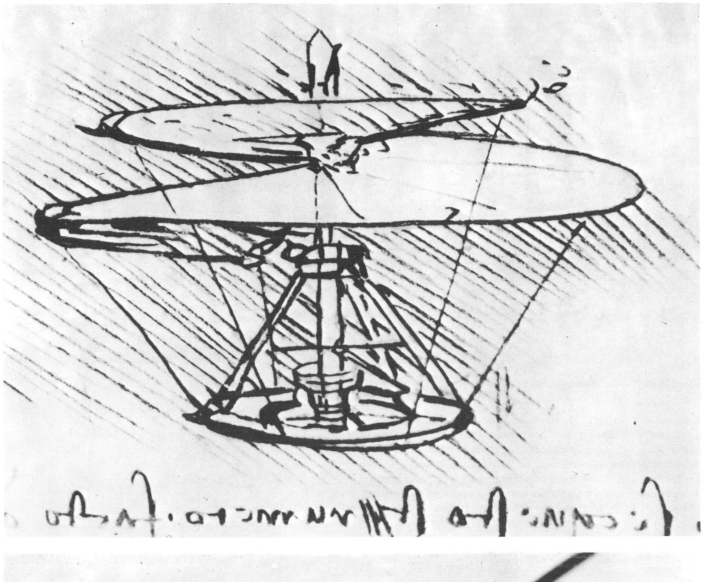

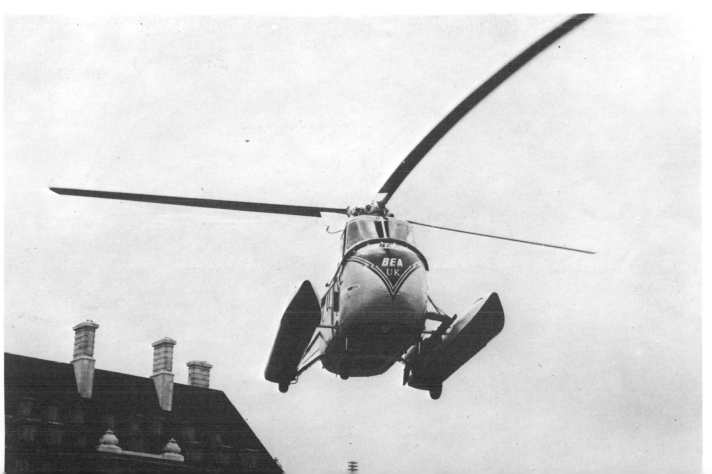

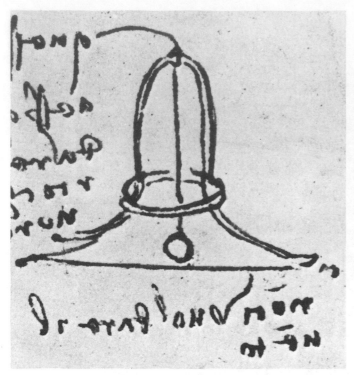

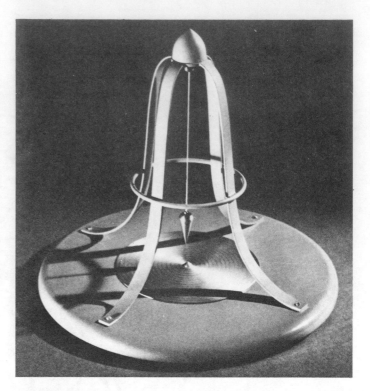

19. *An aircraft inclinometer: c. 1485*

ABOVE RIGHT *Model of the inclinometer*

Early in this period of his aeronautical speculations, and designs for aircraft, there is this surprising little drawing for an inclinometer specifically intended for aircraft: it is an instrument which indicates the attitude of a machine relative to the horizontal, and shows Leonardo considering what may even be felt as comparatively academic matters considering the 'state of the art' of flying at that time. The device consists of a small pendulum hanging in a frame which was to be fixed to the aircraft.

Weapons of War

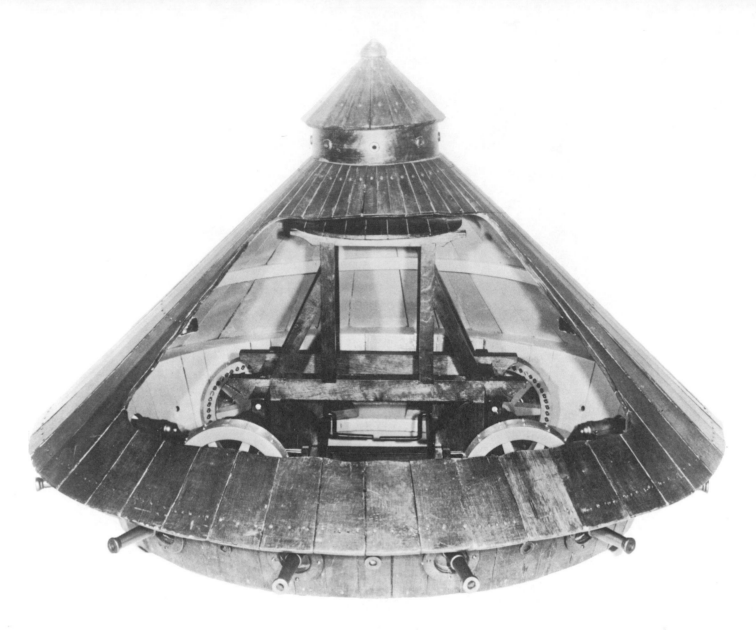

20. ABOVE *Model of armoured tank*

BELOW *Armoured tank*

OPPOSITE TOP *Horse-powered tank*

OPPOSITE BELOW *Tanks in battle line: 1915*

The covered assault car was a common area of research in the military treatises of Leonardo's day and earlier. Valturio and Guido da Vigevano had drawn sail-powered 'tanks' and it is indeed surprising that the world had to wait another 400 years for Churchill's military tank of World War I. Leonardo described

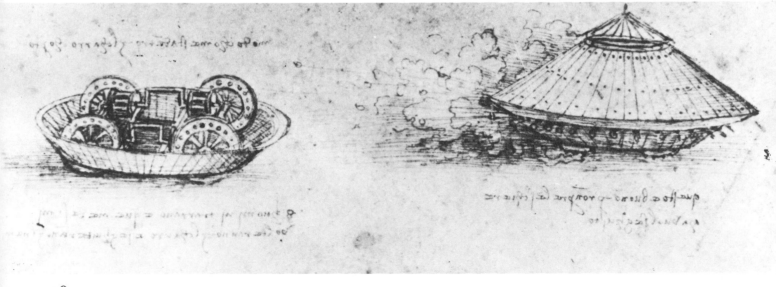

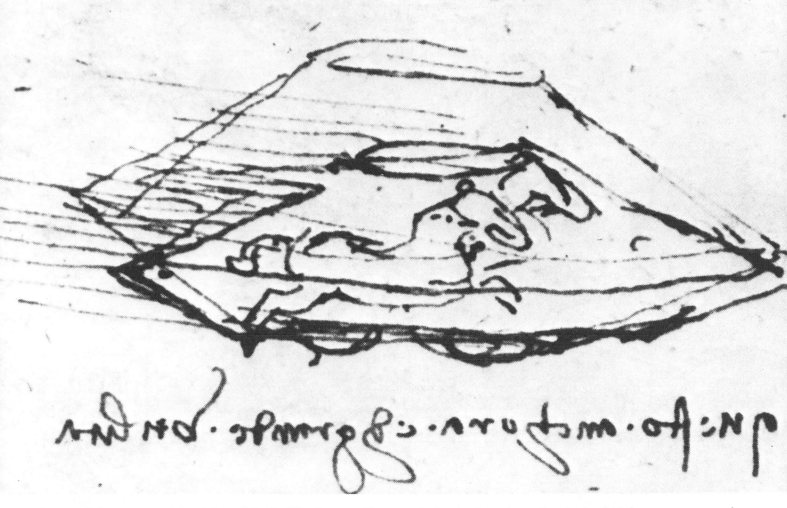

the twentieth-century tank breakthrough in the following way: 'I will make covered chariots which, when they enter among the enemy with their artillery, there is no body of men-at-arms so great but they will shatter it. And behind, infantry will be able to follow quite unharmed and unhindered.'

Leonardo's design had overlapping metal scales for sharp-shooters. The real innovation of his tank compared with those of his predecessors was in its mobility. It was hand-cranked by men or horse-powered, the former being preferable since animals might panic in such a confined, noisy space. The cranks were attached to horizontal trundle wheels which in turn were geared to the four driving wheels. The workings are made clear by Leonardo's plan of the drive mechanism with the top removed.

It cannot be said that Leonardo invented the tank. There are earlier designs and none were ever built to these or Leonardo's own designs. Indeed it is debatable whether Leonardo intended this design to work since the crank as drawn would have powered the front and back wheels in opposite directions. We shall never know whether this was a deliberate mistake made by a man with a conscience or to prevent the design being useful to enemies.

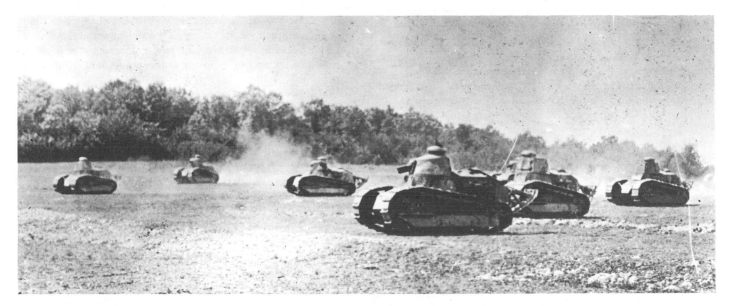

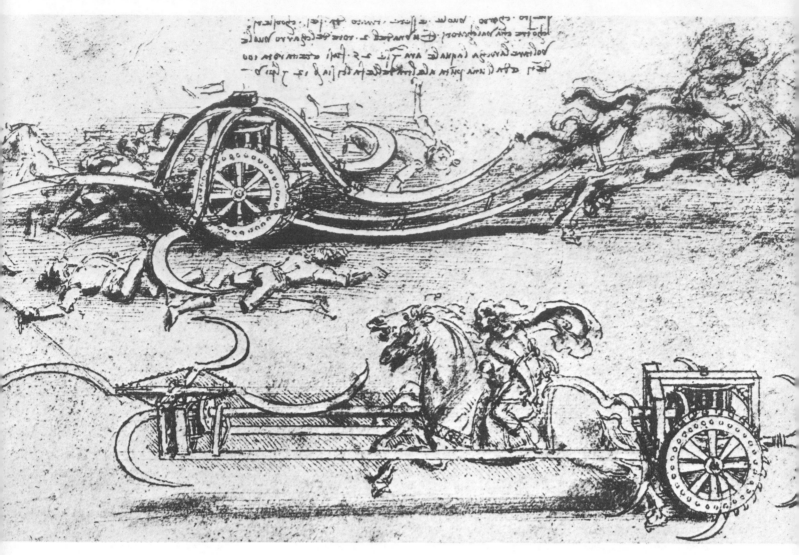

21. *Scythed cars*

Leonardo was a gentle man, said to have been a vegetarian and to have bought caged birds in the market-place only to set them free. This uncharacteristically violent drawing shows mutilation caused by scythed cars drawn by terrified-looking horses. Leonardo seems to have learned of chariots with projecting sickles from Valturio's *De Re Militari* and to have designed a mechanized and more efficient version.

In the upper drawing a pair of horses pull a car whose road wheels turn an upright lantern gear with four huge scythes mounted on top of it like curved helicopter blades. In the lower drawing a similar lantern gear powers a number of smaller blades around the car and also a huge screw turning four large scythes in front of the horses. Leonardo recognized that these awful weapons would probably injure as many friends as enemies.

22. OPPOSITE TOP LEFT *Rope ladders and scaling ladders*

OPPOSITE TOP RIGHT *Fighter scaling a fortress with a rope ladder*

OPPOSITE BELOW *Fighter scaling a wall*

Around 1479, when the Florentine garrisons were under siege, Leonardo naturally became preoccupied with methods of attacking and defending walls. Here again it was a question of going over the methods of medieval military engineers and adding the characteristic touch of ingenuity that is found in so much of Leonardo's work. These three drawings show how Leonardo approached the taking of a wall by assault if a breech could not be made by gunfire. Had mountaineering been a leisure pursuit of Leonardo's day, some of this equipment would have been useful!

The drawings show firstly an assortment of rope ladders and rigid scaling ladders. Some have a grappling iron to hook them over the top of the wall, others a spike to drive into the ground at their base. Secondly, a man is shown scaling the wall of a fortress across a moat with the assistance of a rope ladder very similar to the ratlines used for climbing the masts of sailing ships. Thirdly a man is shown scaling a wall with the help of pitons of various sizes and shapes. As he climbs he makes holes for pitons above him with the help of a sharpened brace, at the same time pulling up a rope ladder for a subsequent assault force.

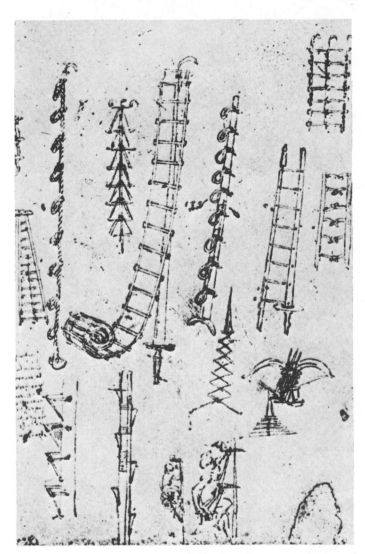

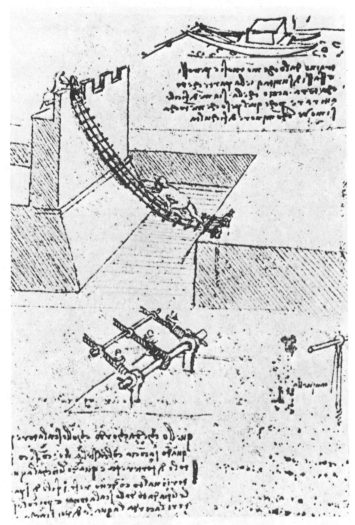

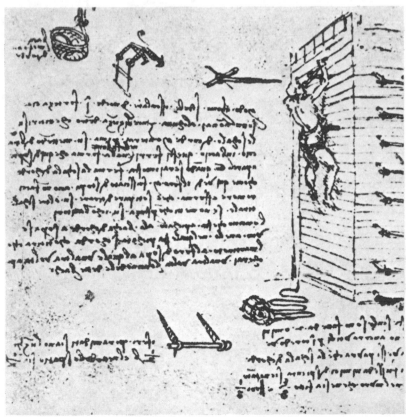

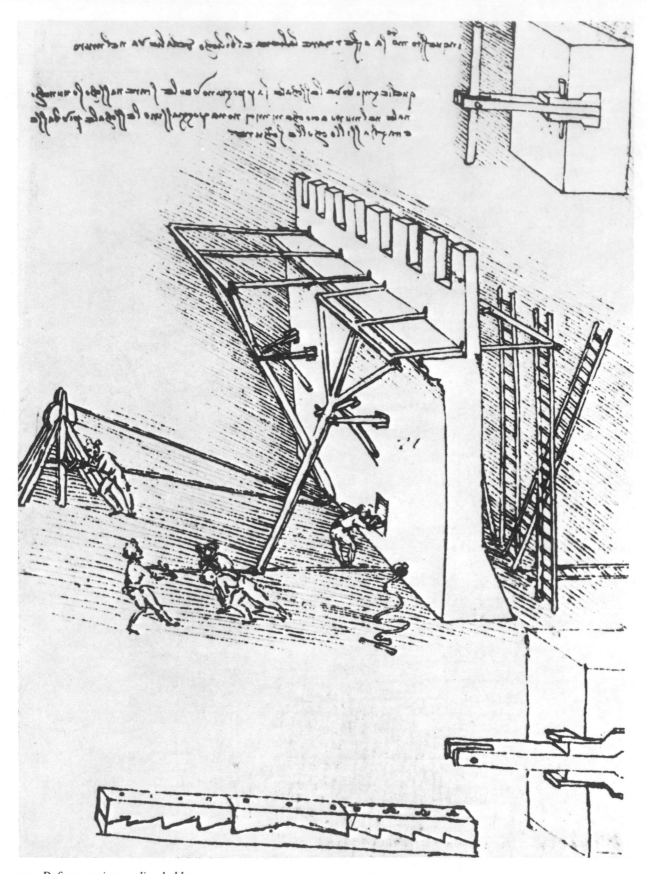

23. *Defence against scaling ladders*

Leonardo suggested two typically ingenious methods of defending a wall against the kind of assaulting ladders he designed himself. One of them, illustrated here, acted rather like a horizontal portcullis, pushing away scaling ladders to the point where they would fall away, while the other was a giant cogwheel which set in motion horizontal sails which swept invaders off the wall like a giant windscreen-wiper. The action of the device illustrated is clearly shown in the clarity of the drawing. It consisted of a horizontal bar on the outside of the wall which could be pushed forward from the inside by men pulling a rope or operating a windlass.

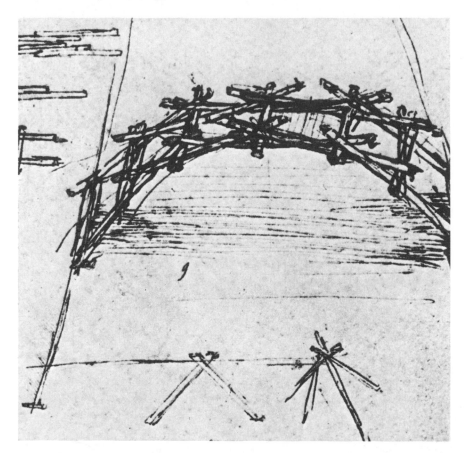

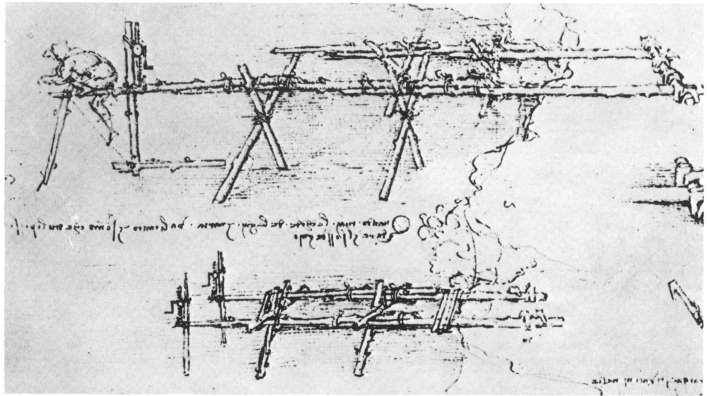

24. TOP *Temporary bridge*

ABOVE *Military flying bridges with jacks*

In his famous letter to Ludovico Sforza Leonardo wrote 'I can construct bridges very light and strong and suitable to be carried very easily, with which to pursue and at times flee from the enemy, and others, solid and indestructible by fire or assault, easy and convenient to transport and place in position.' Here indeed are such bridges. The arched temporary bridge derives its strength from Leonardo's understanding of strains and relative strengths of materials in the construction of arches, while the military flying bridges are both adjustable for height with jacks to allow for crossings between banks of different heights.

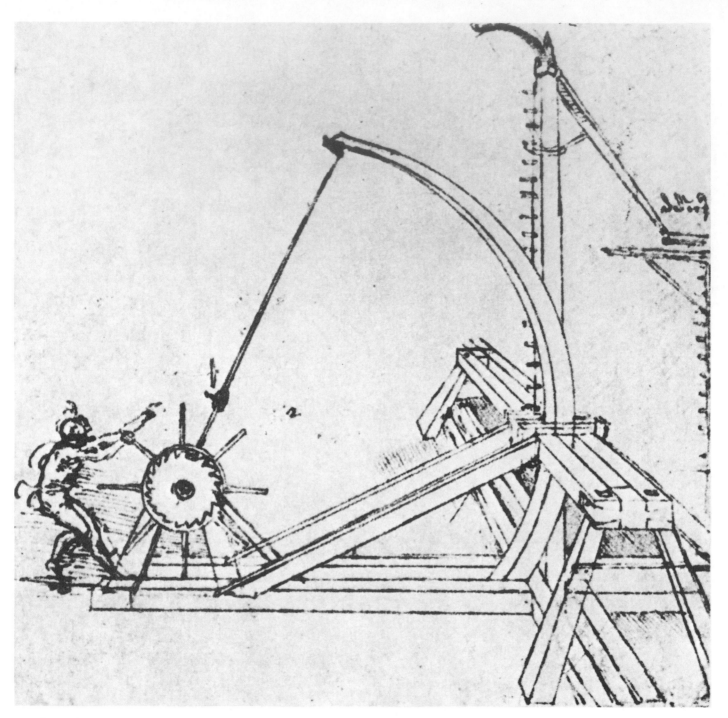

25. *Catapult with ratchet*

Although Leonardo's drawings of artillery are perhaps more visionary and exciting, the more primitive weapons of offence had not entirely disappeared in his day, so he applied his vast abilities to improving them. He took the old forms of ballistas, slings and catapults, added various labour-saving refinements, and produced designs of machines which must have been at least as efficient as contemporary artillery.

This drawing shows a complex and effective catapult which had the virtue of being simple to operate. Its range may have been relatively short, but then guns were low-powered and heavy, and took a long time to reload. This catapult could be reloaded quickly, could be left loaded as a precaution against a surprise attack, and many of them could be mounted on a short section of wall. Also it did not rely on gunpowder.

The operating procedure would have been as follows: a man climbed the ladder to put a stone or missile in the cup at the top of the tapered flexible arm, which was then tensioned by a rope which wound it down to the hand-operated windlass. A toothed wheel with a ratchet, visible at the side of the windlass, held the arm down at the correct tension for the intended range. When the order was given to discharge the weapon, a pin was knocked out of a connection in the rope. It would have been particularly effective against troops advancing in close formation.

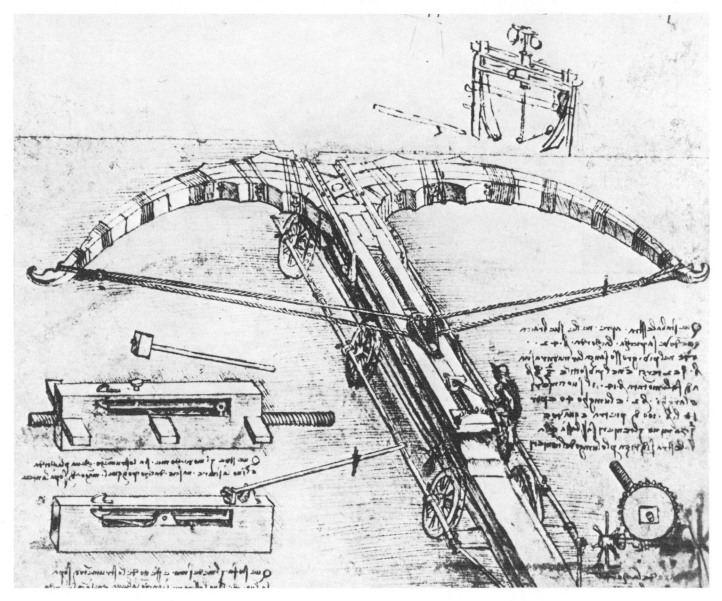

26. *Giant crossbow with six wheels*

In designing mechanical bows and catapults, Leonardo was improving the efficiency of weapons that had been known for centuries. In this case the refinements were extensive and on a vast scale. The crossbow carriage is described by Leonardo as 40 *braccia* long (over 76 feet), while the bow itself would have measured over 42 *braccia* (around 80 feet) from tip to tip.

The drawing itself is a wonderful example of graphic illustration: apart from the details of the great crossbow and its six-wheeled carriage, Leonardo offers a detailed plan of the capstan and screw used to draw the bow at bottom right, while to the left of the main drawing he offers alternative release mechanisms.

Although it has been suggested that the bow was beyond the workshop capacity of the times (the drawing dates from the second half of the 1480s), the construction is very advanced. It

was to be built in laminated sections for maximum flexibility in the bow arms. Each arm was separate but built up and framed together with stout braces. Lashings held the components of each arm while bolts and iron bands held them to the knees and each other. The bowstrings were drawn back by a sleeve attached to the worm and gear, and the missile was released in one of the two ways illustrated on the left. The upper method was by striking a pin with a hammer while the lower involved tripping a latch with a lever and this is shown on the main drawing. Leonardo claimed it was capable of silent operation.

The whole mechanism was mounted on three pairs of wheels, canted to give a more stable firing base and to reduce road shock. The carriage also carried a hinged tail-piece that could be driven into the ground to hold the bow against recoil.

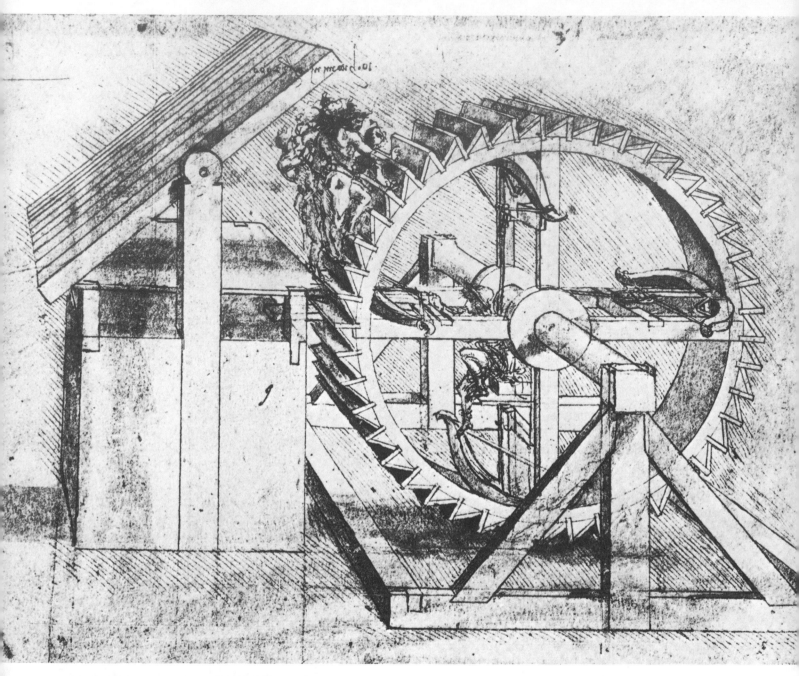

27. ABOVE AND OPPOSITE TOP *Rapid firing crossbow*

This remarkable contraption is the crossbow equivalent of the machine-gun. The great problem with the artillery of Leonardo's day was the time taken to aim and reload the heavy muzzle-loading guns, and although Leonardo designed rapid-fire field-guns, he also produced designs to speed up more traditional weapons.

The archer is suspended inside the huge treadwheel which is turned by a number of men walking its outer rim. They are protected from enemy fire by a very substantial shield of wooden planks. A crossbow is attached to each of the four sets of spokes in the treadwheel, and tension is given to the strings of each bow by

the turning of the wheel in relation to its stationary axle. The archer has simply to trigger each crossbow as it descends to a point where it can be aimed through the slot to the left, underneath the platform for those on the treadwheel. The wheel was probably held still while the archer was taking aim by the board seen protruding through the treadwheel under the crossbow to be fired.

Alongside the main drawing is a second smaller sketch (OPPOSITE TOP), probably a hasty, preliminary view of the crossbow wheel in motion to give an impression of the activity of its operators.

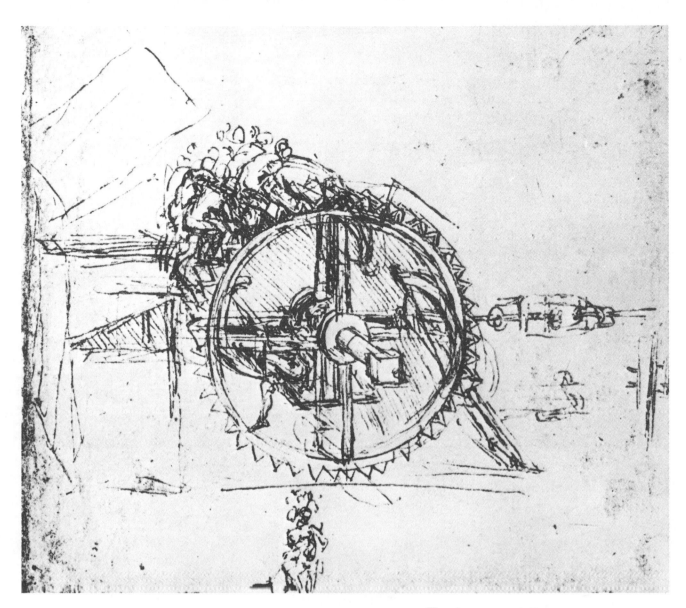

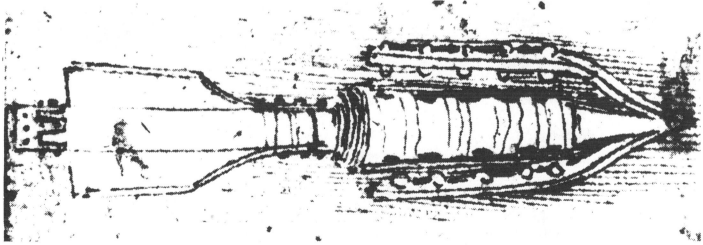

28. *Finned missile*

This deadly looking missile was possibly meant to be launched from a catapult, one of the oldest siege weapons, yet it resembles a high explosive shell of recent times. Thus it looks backwards and forwards in military history, for only Leonardo could combine ancient and modern in such a way.

Leonardo lived in an age in which gunpowder was used to fire crude cannonballs from roughly cast barrels, yet this dart had two broad fins on its tail for directional stability. On impact the strikers along the two 'horns' running back from the tip of the dart recessed into holes and ignited the gunpowder inside the dart. Explosive shells became a preoccupation of the Napoleonic Wars in the 1800s yet it seems Leonardo had many of the design features in hand over 300 years earlier when delivery was still dependent on twisted ropes and bent wooden arms.

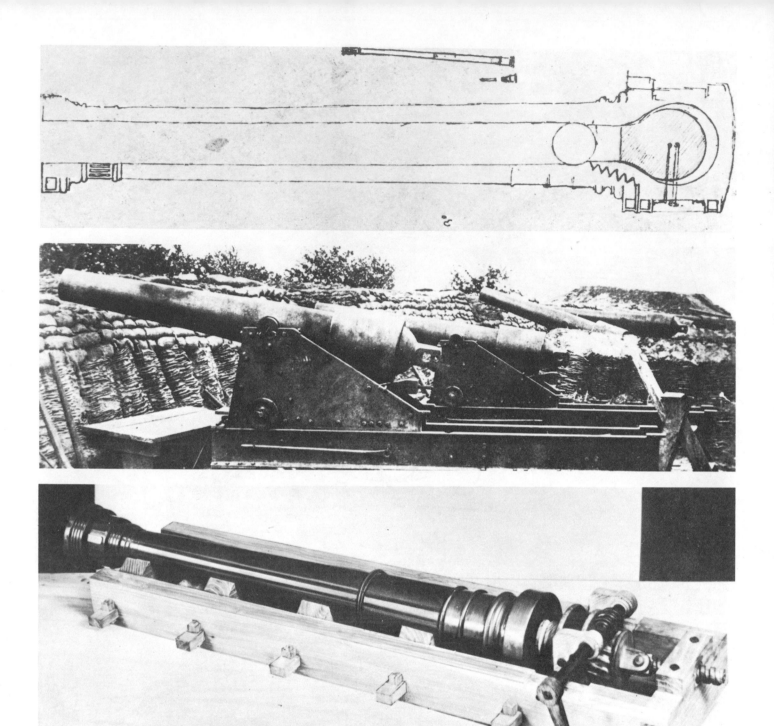

29. TOP *Breech-loading cannon*

CENTRE *No. 1 Battery, Yorktown, Virginia, 1862*

ABOVE *Model of breech-loading cannon*

Leonardo's artillery designs stand quite outside their time. They are more reminiscent of the period since 1850 than of the late fifteenth and early sixteenth centuries, and this drawing is a case in point.

The typical cannon of the years around 1500 was a simple casting in iron or bronze with a short barrel, short calibre and short range. Round cannonballs fitted approximately. Since the casting was in one piece, the breech was closed and this remained the normal design until forgings came into use in the second half of the nineteenth century. Thus the weapons of Waterloo and Trafalgar were muzzle-loaders of the same basic design as in Leonardo's day. Yet in Leonardo's notes on artillery there are no references to single-cast muzzle-loaders: he looked beyond them to the day when true and accurate guns would come from the making of a tube open at both ends with a separate breech-block.

Although this drawing appears in the *Codex Atlanticus* without comment, it clearly has a separate breech-block with a large powder chamber. It fitted into the gun-barrel with a conical screw and could thus be detached for breech-loading in the modern manner.

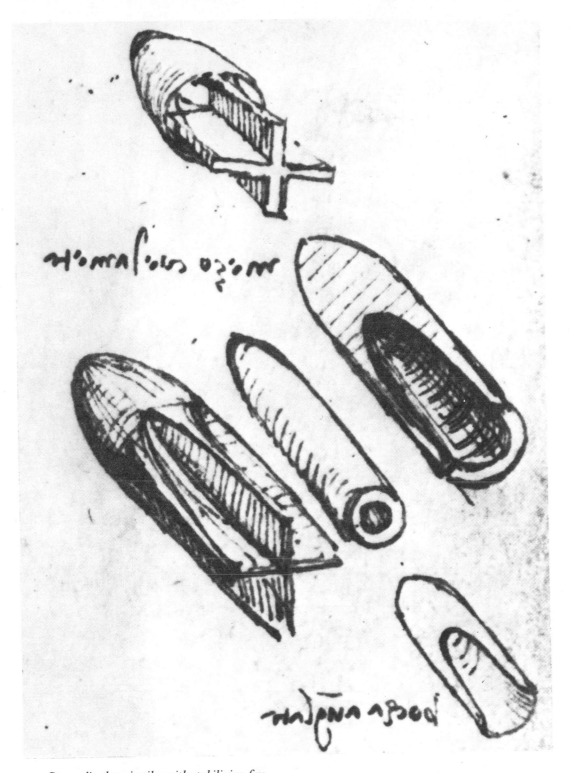

30. *Streamlined projectiles with stabilizing fins*

If Leonardo was to improve artillery design, it was necessary to examine ammunition as well. Up to the late seventeenth century it was assumed in military treatises that cannonball trajectories could be depicted as two straight lines joined by a short curved section, with the second straight line vertical. By examining the curves described by jets of water, Leonardo began to suspect the importance of air re-sistance in producing the deformed parabolic curves of projectiles. He did not manage to provide a mathematical solution of the ballistic curve involving air resistance (Newton did this in 1687) but realization of the importance of air resistance made him contemplate streamlined missiles with stabilizing fins to lessen air resistance to them.

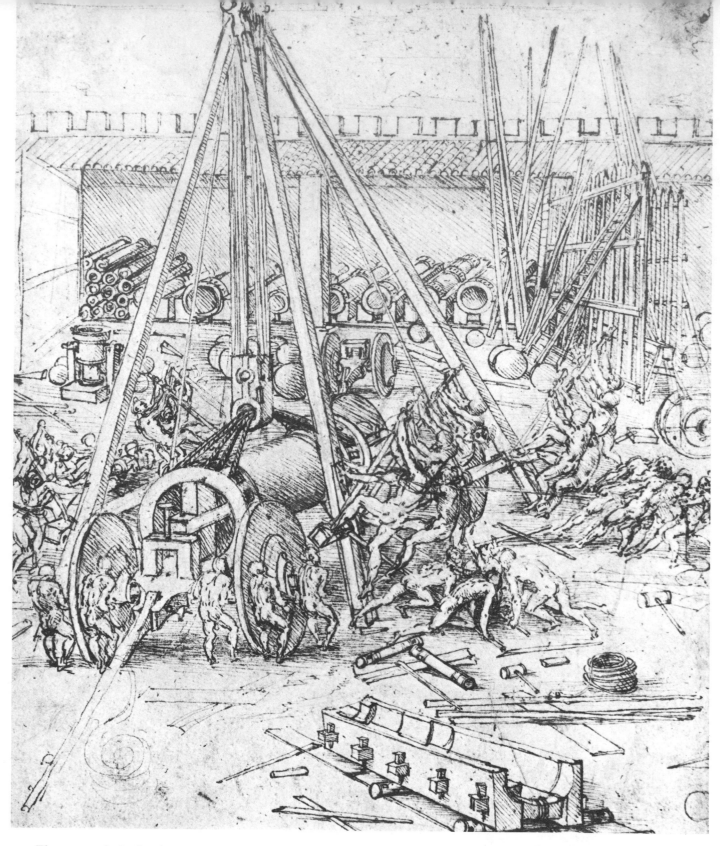

31. *The courtyard of a foundry*

This well known pen and ink drawing depicts a busy scene in an arsenal, in which a huge cannon is being raised onto a gun-carriage. While some of the large labour force strain to lift the cannon with levers and ropes, others are pushing the gun-carriage under the suspended cannon.

While the drawing is very attractive in the activity it captures, it contains little of engineering originality. It does, however, convey something of late fifteenth-century hauling and lifting procedures. The foreground activity involves sheer legs, pulley and tackle, and large levers used in an organized way. In the background, an impression is given of a very well ordered store: there are neatly stacked poles, cannonballs and gun-barrels of various sizes under the shelter of a roof.

The drawing was probably made in about 1487 when Leonardo was looking around the foundries of Milan, in search of ideas to help in the casting of the colossal equestrian statue commissioned by Ludovico Sforza in honour of his father. Possibly it is a sketch for the title-page of a book.

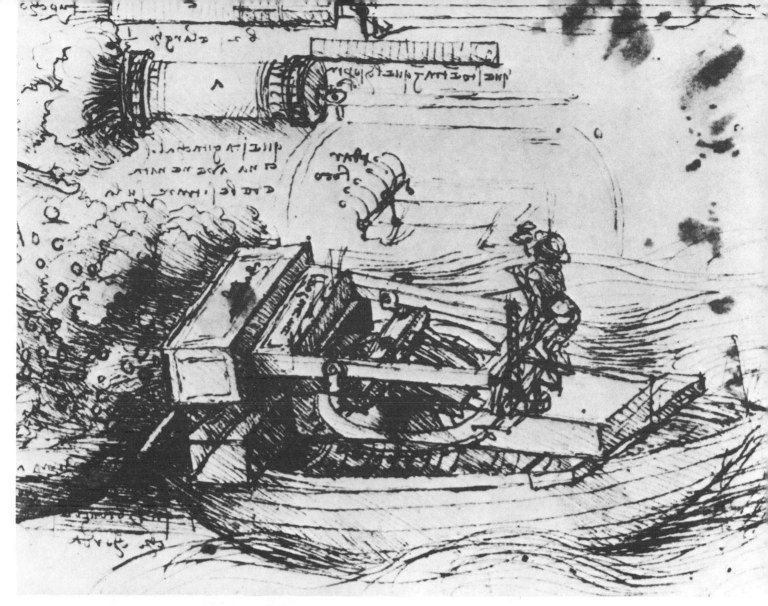

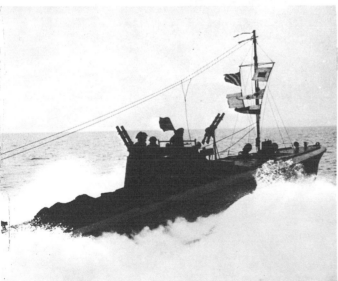

32. ABOVE *One-man pocket battleship, and other innovations in artillery*

LEFT *Motor torpedo boat: 1940*

Fireworks reached Europe late in the thirteenth century, and gunpowder firearms were in use early in the fourteenth century. By 1350 cannon were normal in warfare, and as casting replaced early riveted, brazed or welded barrels they grew in size and weight to become very cumbersome – up to 600 lbs in the early fifteenth century. This made Leonardo think about ways of making guns more easy to move, load and fire.

In this drawing Leonardo suggests two remote-control guns, a multiple-firing mechanism and a one-man pocket battleship. The two guns at the top of the page were to be mounted on the end of long poles. The upper one is to be fired by a tinder on a lever worked by a long string, while the lower gun is to be recharged with gunpowder from a long tube. Just below is a set of tinders for firing a six-barrelled gun.

The captain of the one-man battleship that dominates the page is in command of a box-shaped mortar mounted on a revolving platform built onto a small boat. The mortar is discharging a Greek fire of incendiary materials designed to set fire to enemy ships. In concept it is similar to motor torpedo boats of the Second World War. Elsewhere in Leonardo's works are to be found ideas for incendiary bombs and his own prescriptions for gunpowder manufacture – his favourite recipe had the ingredients moistened with brandy and dried in the sun!

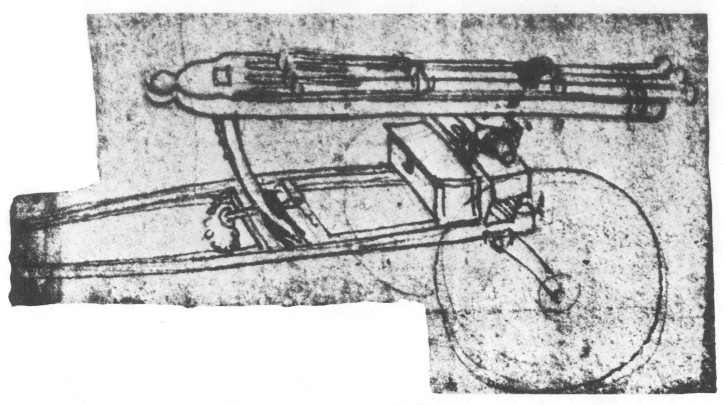

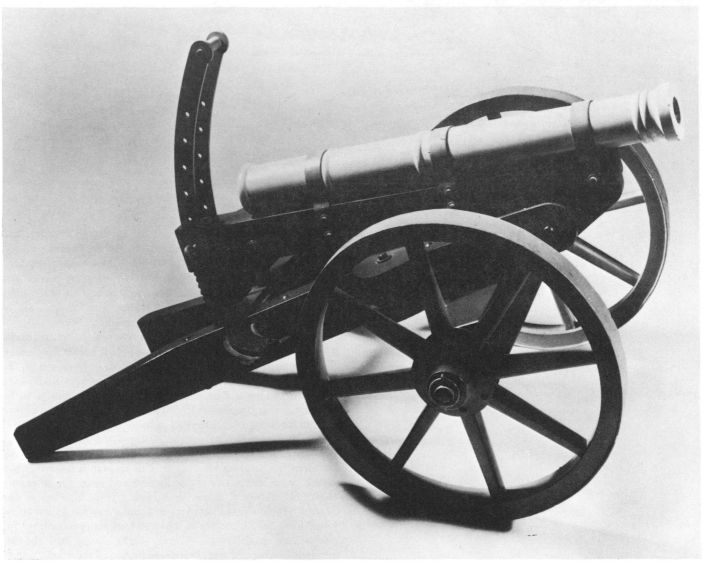

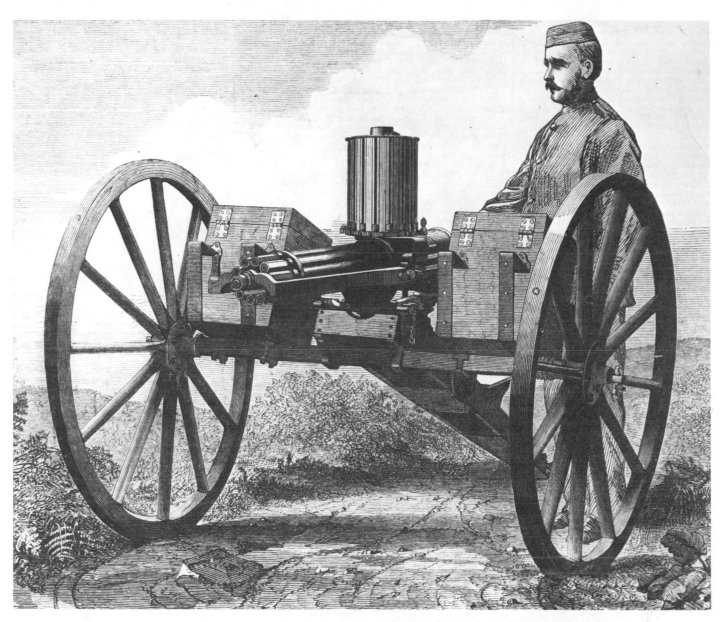

33. OPPOSITE TOP *Light field-cannon with three barrels*

OPPOSITE BELOW *Model of gun carriage*

ABOVE *Gatling gun*

In Leonardo's day, guns were used mainly in siege work because they could operate from fixed positions (being too heavy to move quickly) and still do damage despite their short range. In the field they took too long to load and move, and even a short retreat left them in enemy hands since it was too dangerous to use them in anything other than front-line positions. Leonardo therefore tried to overcome the defects of the standard gun of his day by designing field weapons that were easily moved and which fired quickly.

In this drawing Leonardo approaches the structure of the Gatling gun. It is on wheels, has three breech-loading barrels, elevation is secured by rack and pinion, and a large ammunition chest is carried under the barrels. The whole weapon seems more characteristic of the American Civil War period than of a time more than three centuries earlier.

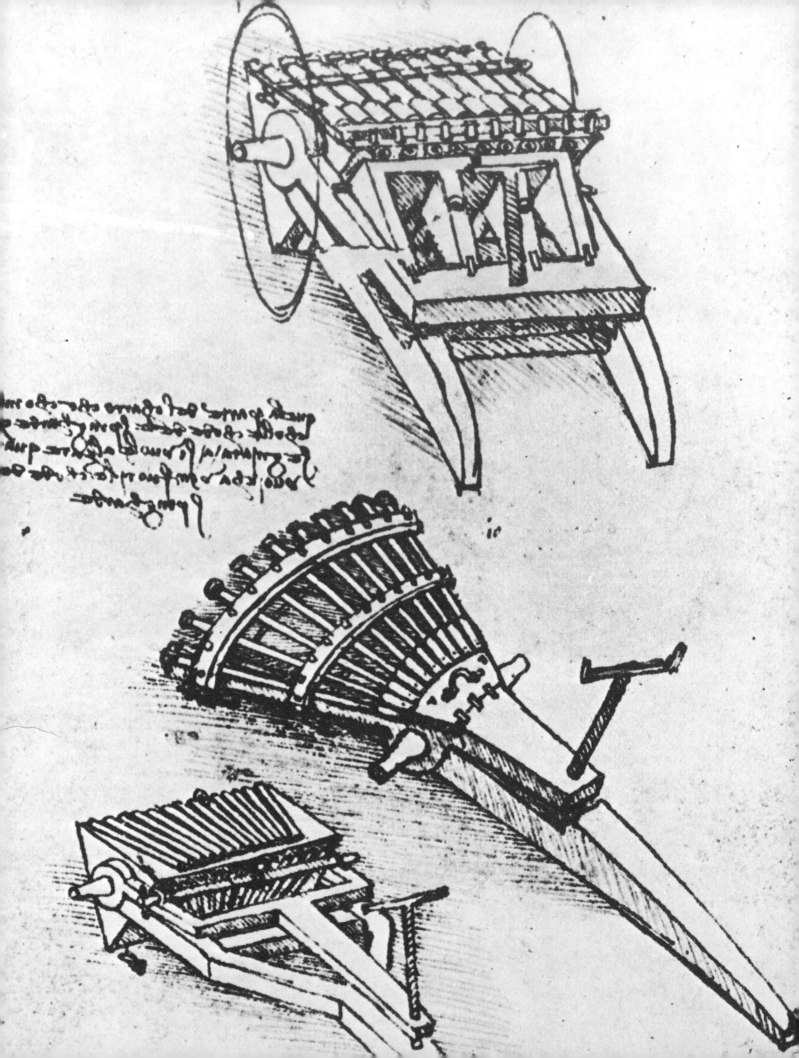

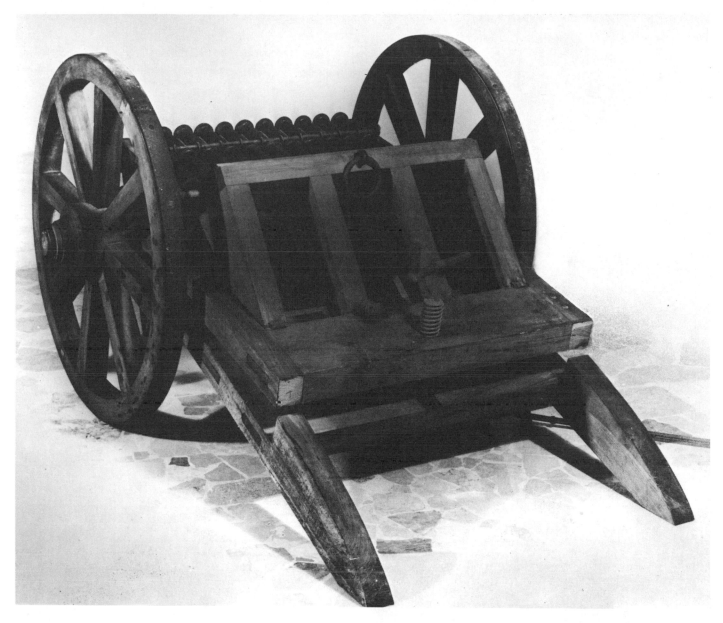

34. OPPOSITE *Multiple-barrelled machine-guns*

ABOVE *Model of multi-barrelled machine-gun*

The idea of the multiple-barrelled gun was not entirely Leonardo's. The German Konrad Kyeser had drawn such a design as early as 1405, but with the emphasis on lightness and speed of operation, Leonardo's designs are much more sophisticated and suggestive of American Civil War technology.

Like the Gatling and Maxim guns, the idea was simple. In the top and bottom drawings three racks of eleven and fourteen cannons are mounted in triangular shape on the rotating axis of the gun carriage. While the forward-pointing rack was being fired the gunners could load the next rack to be brought up into firing position. The third rack would come up for reloading as the first was cooling off. All three batteries were adjustable for elevation with a screw-jack. The centre drawing shows a single rack of guns with the barrels spread to allow wide scattering of shot. In each case, Leonardo must have envisaged the possibility of firing all barrels at once since there are drawings of multiple tinder racks among other gun designs.

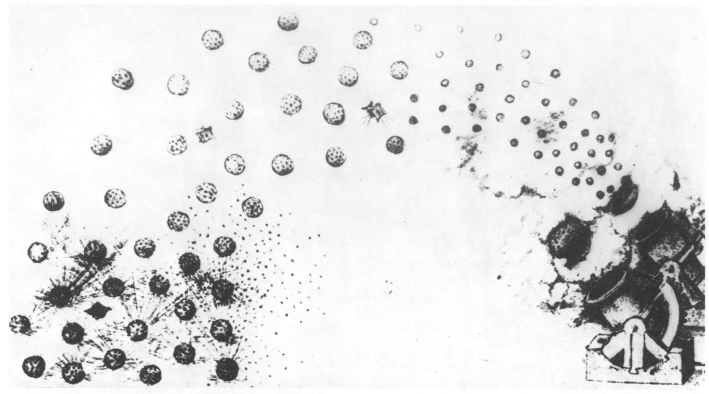

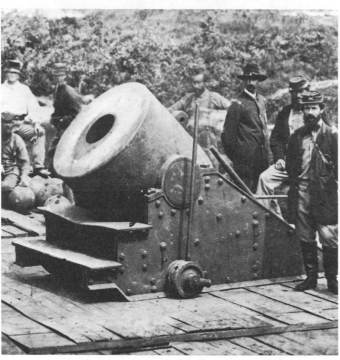

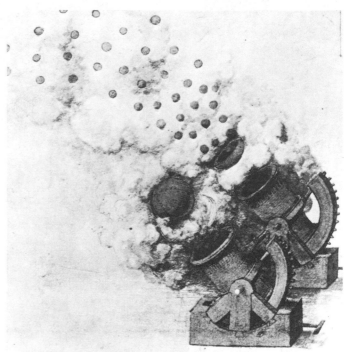

35. TOP AND ABOVE RIGHT *Mortar with explosive projectiles*

ABOVE LEFT *The mortar 'Dictator' used in the American Civil War: 1865*

To produce rapid and scattering fire even more deadly than that of his machine-guns, Leonardo designed mortars and explosive fireballs. The mortars bear a quite striking resemblance to those of the mid-nineteenth century used in the American Civil War and as bombards on naval vessels. Leonardo's drawings show that the mortars were elevated by a toothed semicircle operated by a hand-crank.

Perhaps more interesting than the mortars themselves is the shrapnel-shell Leonardo designed to be fired by such weapons. Their deadly effects are clearly visible: the large container ball has a jointed covering which splits as it leaves the mortar, releasing smaller balls filled with holes so that they explode on impact scattering shrapnel. As soon as one of the small bombs exploded the others would scatter and fire, in Leonardo's words, 'in such time as is needed to say an Ave Maria.'

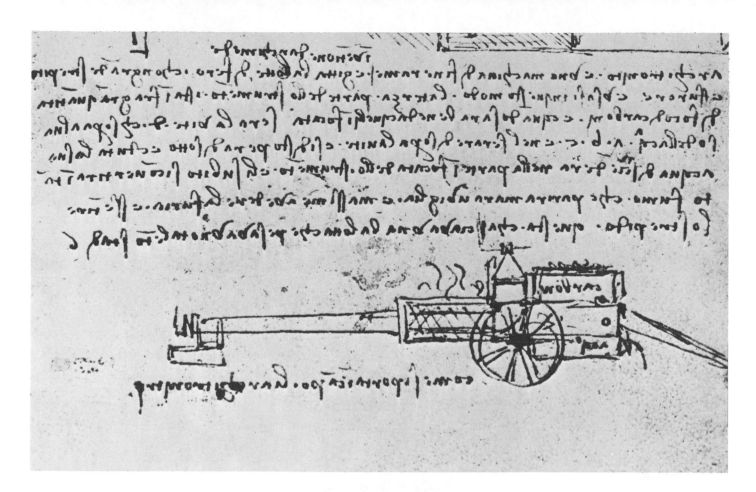

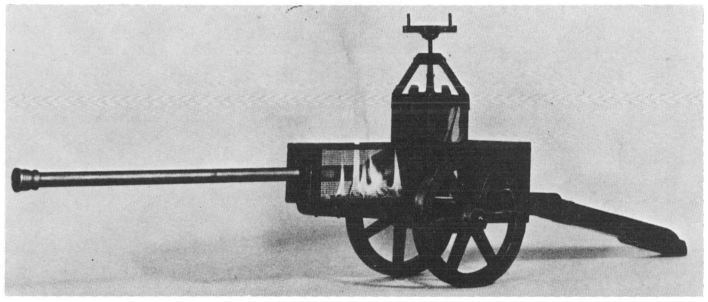

36. TOP *Steam cannon*

ABOVE *Model of steam cannon*

Clearly Leonardo knew of and experimented with the use of steam as a source of mechanical power. In *Manuscript B*, which is largely concerned with military matters, is a series of drawings of a steam cannon for which Leonardo coined the name 'Architronito'. It was to be made of copper, and was designed to blast an iron ball out of a gun-barrel with the sudden application of steam. The breech of the cannon was built into a brazier of burning coals which would heat it to very high temperatures. Then a small amount of water would be injected into the equivalent of the powder chamber just behind the iron ball. The water would instantly convert to a large head of steam driving the ball out with a great roar. Screw valves were provided to control the sudden injection of water.

Since Leonardo quoted figures of how far the *Architronito* would drive a cannonball of given weight, it is possible that one was actually built, many centuries before the steam cannon of the American Civil War. Certainly the method shows a way of putting the expansive power of steam to work centuries before the steam engine. Also illustrated is a recent model of the steam cannon.

Elements of Machines

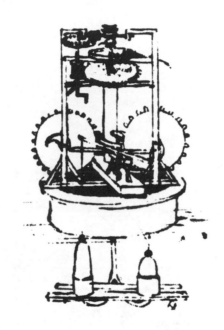

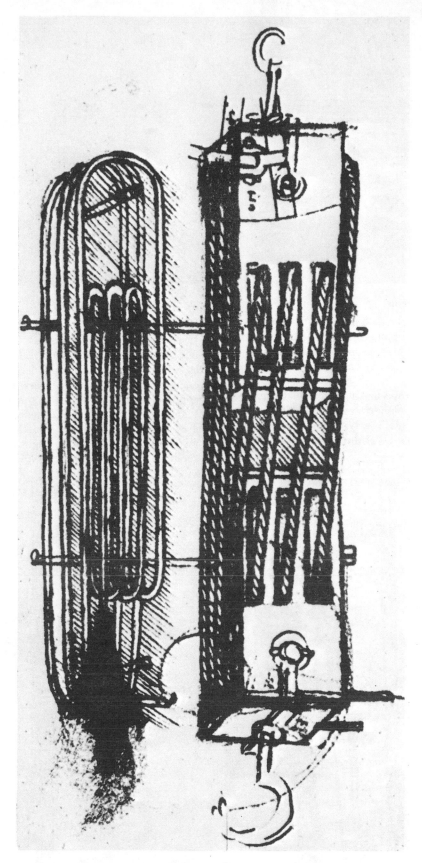

37. *Tackle for the study of tension in ropes*

Studies of pulleys and tackle of various types abound in the *Codex Atlanticus* not just because Leonardo was searching for more efficient ways of lifting heavy loads, but because he was interested in the theoretical concept of force. Ropes drawn through fixed or movable pulleys were the means to experiment in solving the problem of the decomposition of force along two or more lines of direction.

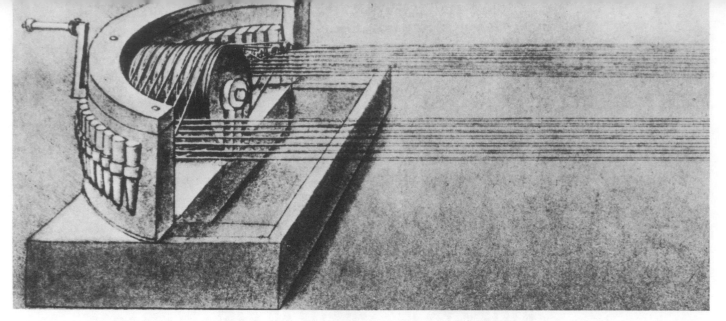

38. ABOVE *Rope-making machine*

Leonardo's achievements in the field of textile machinery were considerable. He designed clipping machines, shearing machines, automatic spindles and, here, a rope-twisting machine. His works anticipated many of the inventions of the industrial revolution.

There are two designs for rope-making machines in the *Codex Atlanticus*. This is the more complex, spinning and twisting no fewer than fifteen strands simultaneously. Evenly spun ropes were a prerequisite for Leonardo's experiments in tension through tackle and pulleys.

39. BELOW LEFT *Lifting jack*

BELOW RIGHT *Model of lifting jack*

It has been said that if cans had existed in Leonardo's day, he would have invented a can-opener. In this drawing he seems close to a modern lifting jack as used on motorcars. It consists of a cranked handle, reducing gears and a rack. The workshop applications for such a jack would have been numerous in Leonardo's day, but it remains difficult to say how far this drawing is a description of something in general use, how far a modification or how far an original invention. It is, however, a good and self-explanatory example of technical illustration.

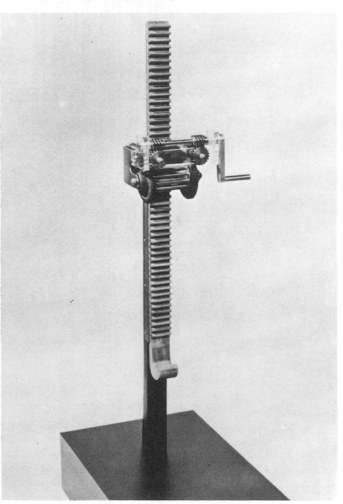

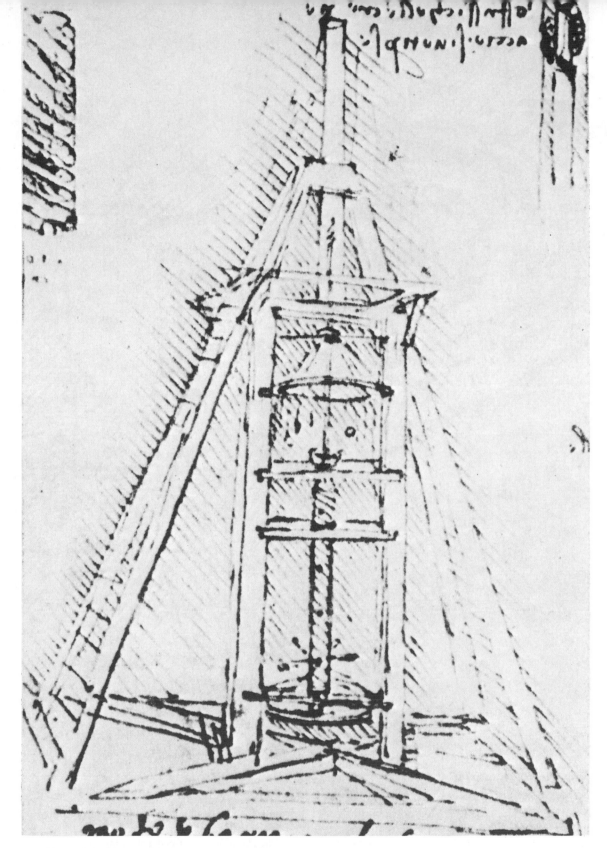

40. *Vertical drilling machine*

Leonardo paid a great deal of attention to the designing of drilling and boring machines. Water supply depended on such devices: they were needed to make wooden pipes by drilling through tree trunks and to find water by digging wells. In this drawing Leonardo suggests a workshop vertical drilling machine to make wooden pipes. The trunk to be bored is held firmly and vertically in the top of the machine frame, while the drill bit moves upwards from below, turned by a capstan and raised by a screw. The idea of boring upwards was to enable the sawdust to fall away from the hole as it was formed. With a constant eye for detail, Leonardo even provided the central shaft with a cone-shaped umbrella to keep the sawdust off the machine operators. The Dresden engineer Peschel developed a machine like this one around 300 years later in 1798.

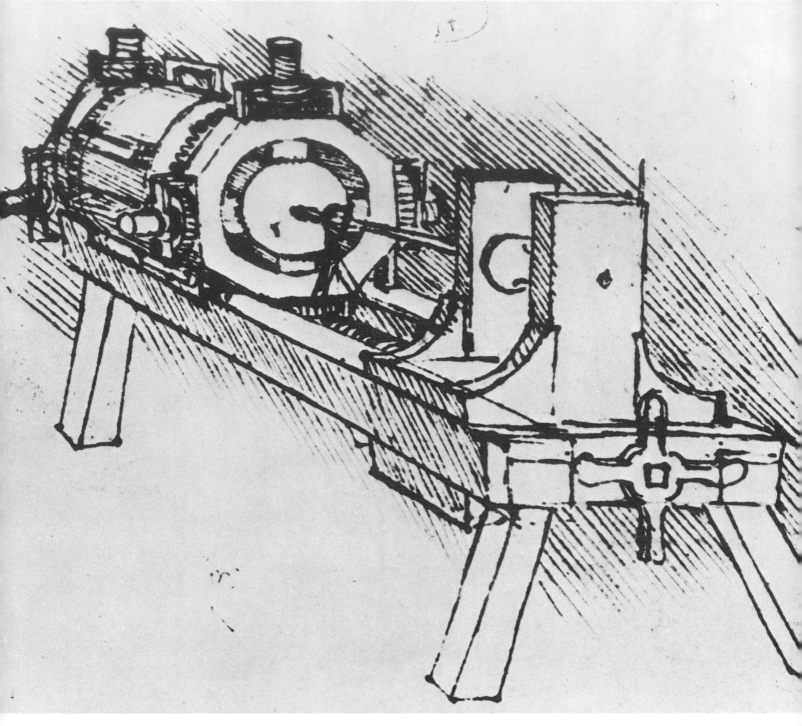

41. **ABOVE** *Horizontal drilling machine*

OPPOSITE *Model of the horizontal drilling machine*

This drawing appears without accompanying notes in the *Codex Atlanticus*, and, on first sight, bears a startling resemblance to a modern lathe. It is in fact a horizontal alternative to the vertical drilling machine previously illustrated with the same purpose – drilling holes in logs for use as water mains (Fig. 40). As the hole was being bored, the drill and the log were brought closer together by the screw, seen faintly between the sides of the frame, turned by an end wheel of four spokes. The log was clamped from all four sides by adjustable chucks, keeping its axis in line with the drill regardless of size.

The startlingly modern appearance of this piece of workshop technology is made still more mysterious by the fact that none of Leonardo's written works were published until over 130 years after his death, yet in design it appears to belong to the age of industrialization.

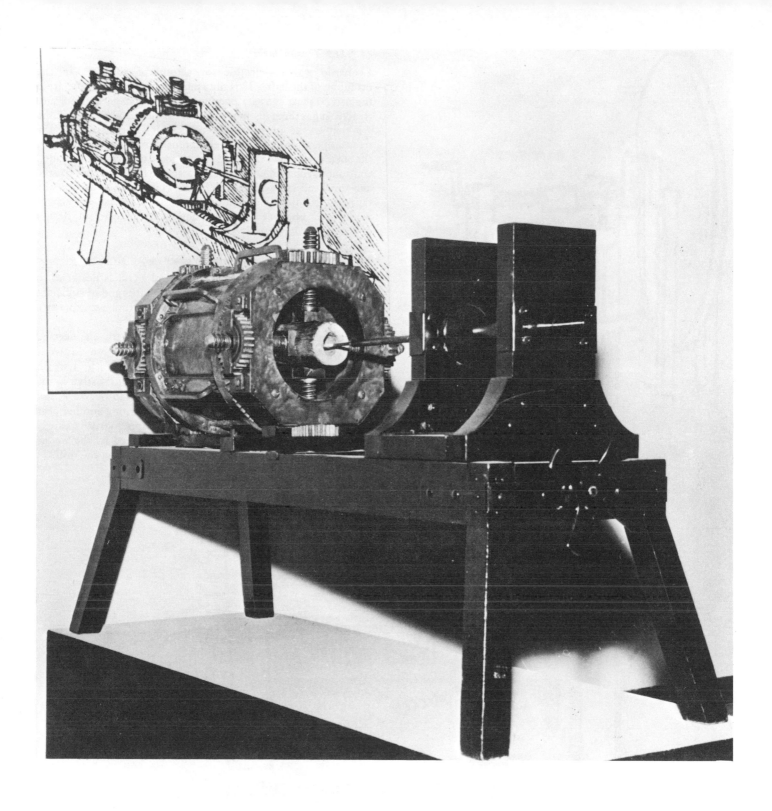

42. LEFT *Treadle lathe*

Leonardo was responsible for significant advances in the evolution of the lathe. This drawing, which probably dates from the early 1480s, shows a combination of a flywheel, crank and treadle. It has three distinct advantages over earlier types of lathe – it enabled the operator to keep his hands free (because of the treadle operation), the flywheel's momentum would have carried the machine over its dead spot, and the crank provided continuous rotation unlike the reversing action of earlier treadle and overhead spring lathes. The drawing even shows that the tail-stock is adjustable by means of a thread to take any size of workpiece. The overall impression is of an efficient design depicted in a delightfully simple drawing.

43. BELOW *A small rolling-mill to make copper strips*

This machine, which dates from around 1515, is designed to stretch and roll copper strips into equal lengths and of sufficient evenness and thinness for the making of mirrors, an expensive household luxury of Leonardo's day.

Leonardo's great influence on the origins of early engineering drawing is evident in the way two views of the machine are given: an elevation and a plan. The machine was powered by a winch (though a waterwheel is suggested as a better alternative in the notes) which turns a large horizontal gear wheel through a worm. The wheel's shaft has a second worm on it turning another gear wheel onto the shaft around which the copper strip is slowly wound. The strip passes through dies pressured by the wedge which sticks up above where the copper is entering the mill.

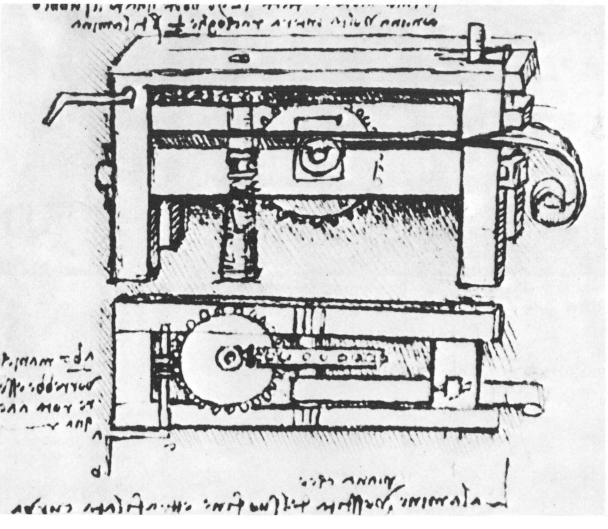

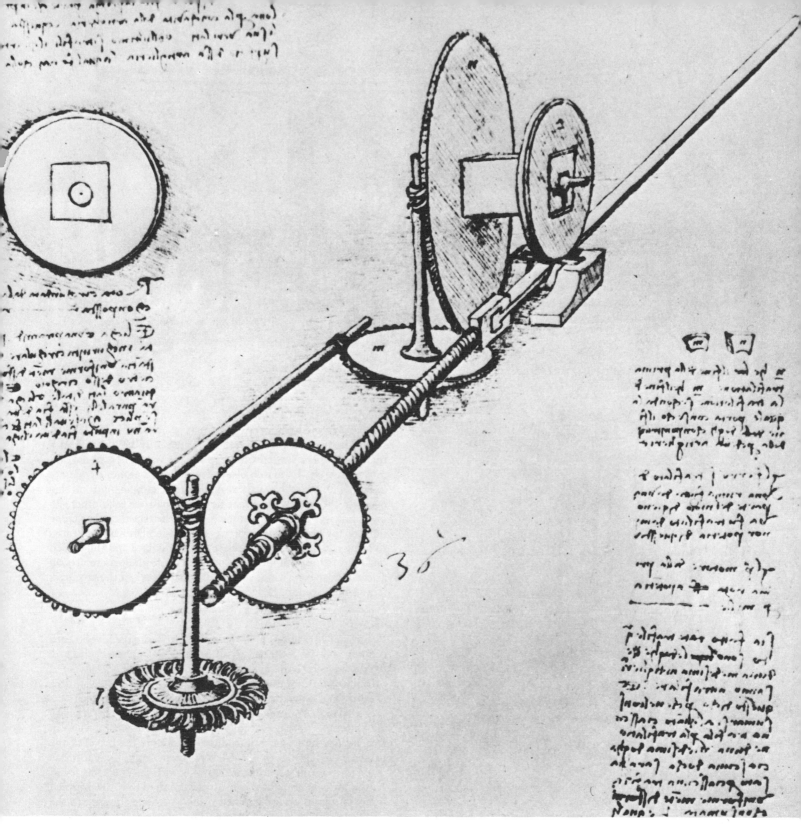

44. *Water-powered machine for drawing cannon staves*

Leonardo lived in the days of transition from archery to gunpowder, and he therefore applied his mind to artillery. He designed breech-loading guns and flighted missiles, but also had in mind the design of guns too large to be cast. This drawing depicts a water-powered mechanism for forming the stave or segment of a gun-barrel. The barrel would be built up of several of these segments (shown in cross-section to the right of the main drawing) which would be banded or welded together, heavier at the breech section than at the muzzle. All the segments would have to be smooth and even, with a uniform taper, so that a straight gas-proof bore could be obtained. Since hand-forging was not sufficiently accurate, Leonardo designed a machine that would both draw and roll the bars from one power source – in this case a reaction water turbine. Through two sets of worm drives, the sheet iron was simultaneously made to advance while being rolled. In a tiny schematic sketch at the bottom of the page (not illustrated), Leonardo even provided figures of the gearing reduction of the four gear wheels involved. Many of Leonardo's small artillery drawings had design features of the late 1800s, but in this drawing his thoughts seemed to be moving towards the proportions of a late fifteenth-century 'ultimate deterrent'.

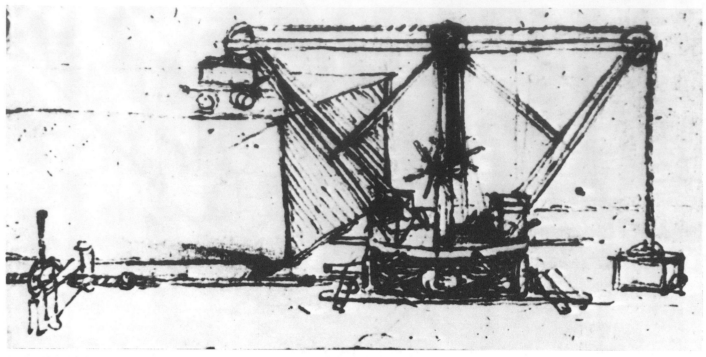

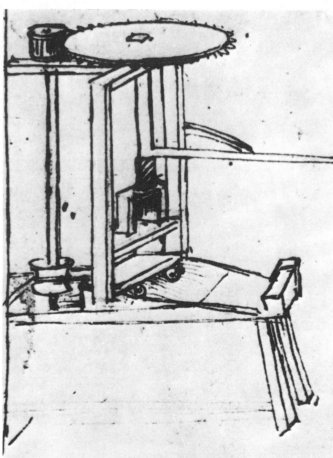

45. ABOVE *Twin cranes*

Leonardo's civil engineering designs were often of a labour-saving nature. These twin cranes, apparently being used in a quarrying operation, enable large stone blocks to be raised and moved quickly. Leonardo elsewhere designed cranes to operate in pairs – to assist in canal excavation for example – but on this occasion the cranes are meant to counterbalance each other. As one crane is loaded with a stone block at the face the other crane unloads the previously cut block. The crane platform then turns to bring the unloaded jib back round to the face and the loaded one away to the dumping position. The crane platform rotates on a rectangular base which can be dragged closer to the face by a large winch seen to the left of the base.

46. LEFT *Printing press*

Printing presses were crude affairs until well into the seventeenth century and the early history of printing is somewhat obscure. Leonardo was born at about the time Gutenberg invented printing from movable type, but it is impossible to relate this drawing to the precise practice of the time it was drawn.

Two possible improvements are suggested. On the left, the use of a double thread, a favourite and recurring device in Leonardo's drawings, is introduced to double the travel of the press for any given turn of the lever. On the right, Leonardo has made the position of the frame movable with the operating lever. As the press is brought down by pulling the lever, the wheeled frame is wound up the inclined plane by a rope attached to the geared axle to the left of the press. The release of the lever allows the frame to descend the inclined plane for resetting.

It is ironic that although Leonardo could suggest these and other improvements to the process of printing, none of the treatises that he intended to publish appeared in print until 132 years after his death: an abstract of his notes on painting was published in Paris in 1651.

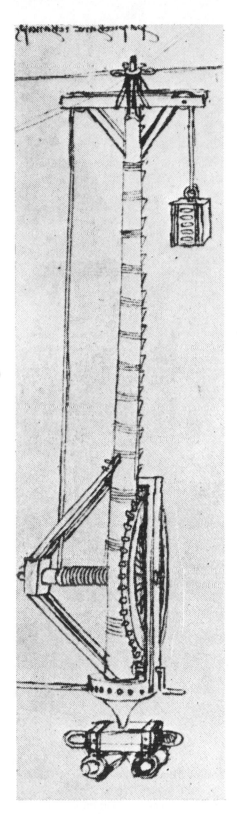

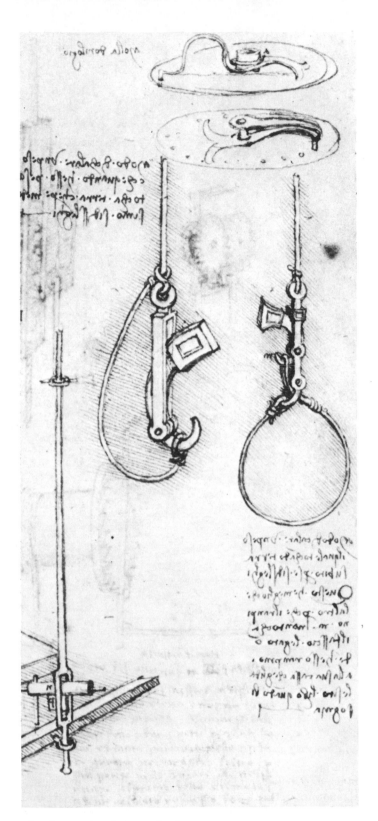

47. Travelling crane

Leonardo designed machines to help the civil engineer both in the workshop, in the form of machine tools, and out of doors in canal-building, drainage, dredging and town-planning schemes. Indoors and out of doors, lifting devices were a day-to-day necessity so Leonardo designed an assortment of jacks, pulleys and cranes.

This crane is designed to travel on its small trolley with overhead guide wires. It can revolve on a pivot and is well geared down to lift heavy weights without being too cumbersome. It might have been used in the construction of tall buildings.

48. Automatic release mechanisms

For use with lifting gear of any kind, these are two automatic releases for depositing loads without the necessity of unhooking them. Each relies on a weighted hook which is kept in position by the greater weight of the load. As soon as the load's weight is relieved by contact with the ground, the hook pivots and uncouples. Leonardo writes in his accompanying notes that the device on the right is preferable because the weighted hook does not come into contact with the load, which could, in the other drawing, prevent the hook from freeing itself.

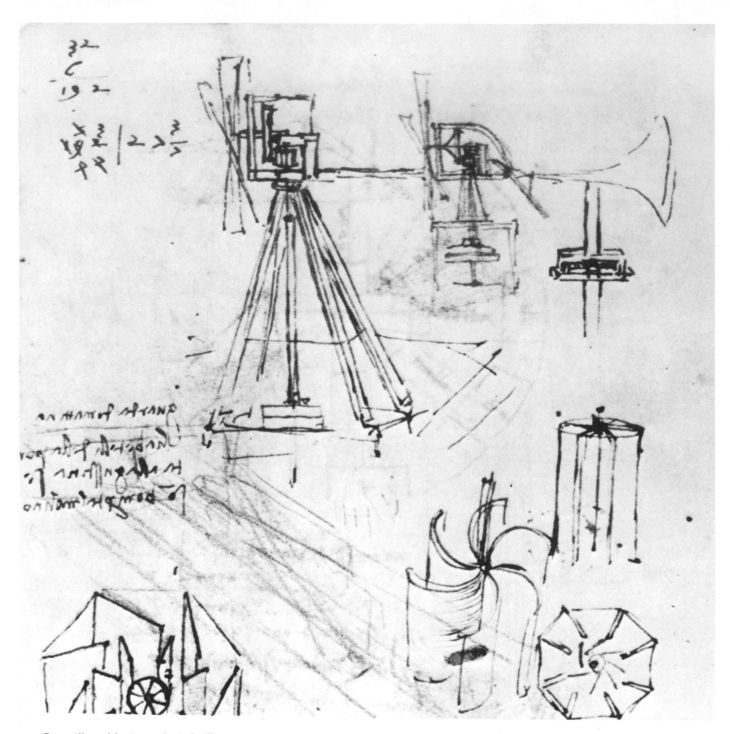

49. *Postmills and horizontal windmills*

This mysterious page from the *Codex Madrid II* puts Leonardo in the forefront of windmill design. Windmills were not of great significance in Italy because of unfavourable weather conditions, and it is thought that Leonardo's interest arose from the offer of his services to the Ottoman Sultan Bazajet II in about 1502. The fact that windmills were a relatively unimportant part of technology in Italy did not stop Leonardo from making some ingenious designs.

At the top of the page are two postmills. They differ from the traditional design in that they are turned into the wind by a large tail fin rather than by a post moved round by hand. For lightness and convenience of operation, Leonardo put the millstones at ground level. The resemblance to modern windpumps is remarkable.

The drawings at the bottom right of the page appear to be sets of sails or armatures for a horizontal mill. This could operate regardless of wind direction, and hitherto the earliest known drawing of such a mill was by Besson in a book published in 1578. At bottom left is a canvas windmill, the only windmill accompanied by a fairly full description by Leonardo. It consists of 32 breadths of cloth up to 25 *braccia* (48 feet) in height. Unfortunately Leonardo's words do not make it clear whether all the sails turn on a framework as in a modern Chinese windmill or whether their function was to duct the wind onto a central armature. Leonardo was in no doubt as to its cost-effectiveness: he gives the prices of the materials and labour in building it and writes 'know that this mill has such a power that its wheel may drive two pairs of millstones. It is strong and grinds with every wind.'

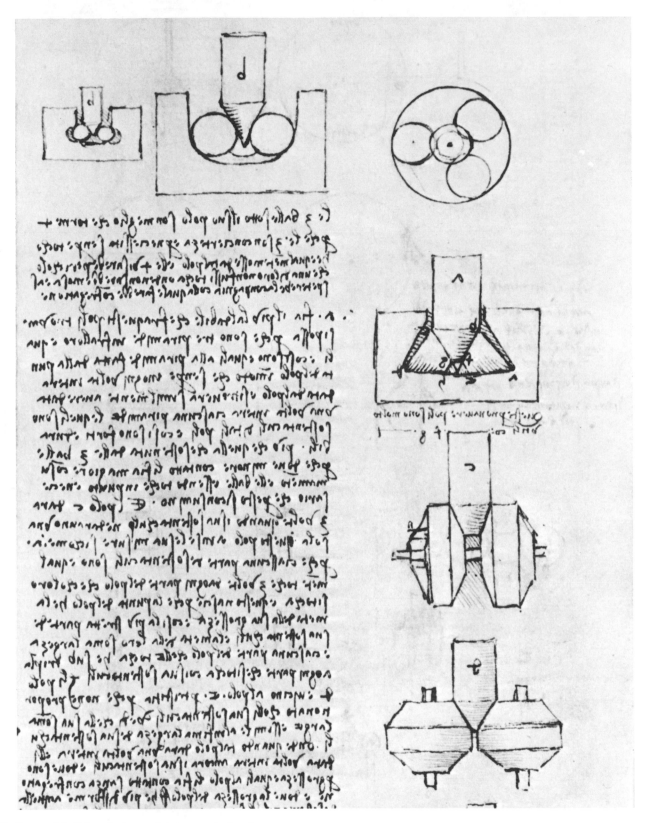

50. Roller- and ball-bearings sustaining a vertical axle

Since time immemorial engineers have tried to use rolling objects between shaft and bearing to reduce friction. Disc bearings may have been known before Leonardo in Europe and other types of bearing in ancient China, but the true roller- and ball-bearings in these drawings constitute the first modern attempt to solve friction problems in machinery. The array of drawings shows Leonardo thought there was little to choose between roller- and ball-bearings, but he did try to think of ways of keeping the rollers or balls from touching each other, and of thus reducing friction. Hence the three-ball drawings at the top of the page. The arrangement of three balls nested around a conical pivot was reinvented in the 1920s for aircraft gyro instruments, while roller-bearings were reinvented and patented for use on road vehicles in the late eighteenth century. Other drawings of block bearings in *Codex Madrid I* presupposed the advent of low-friction materials.

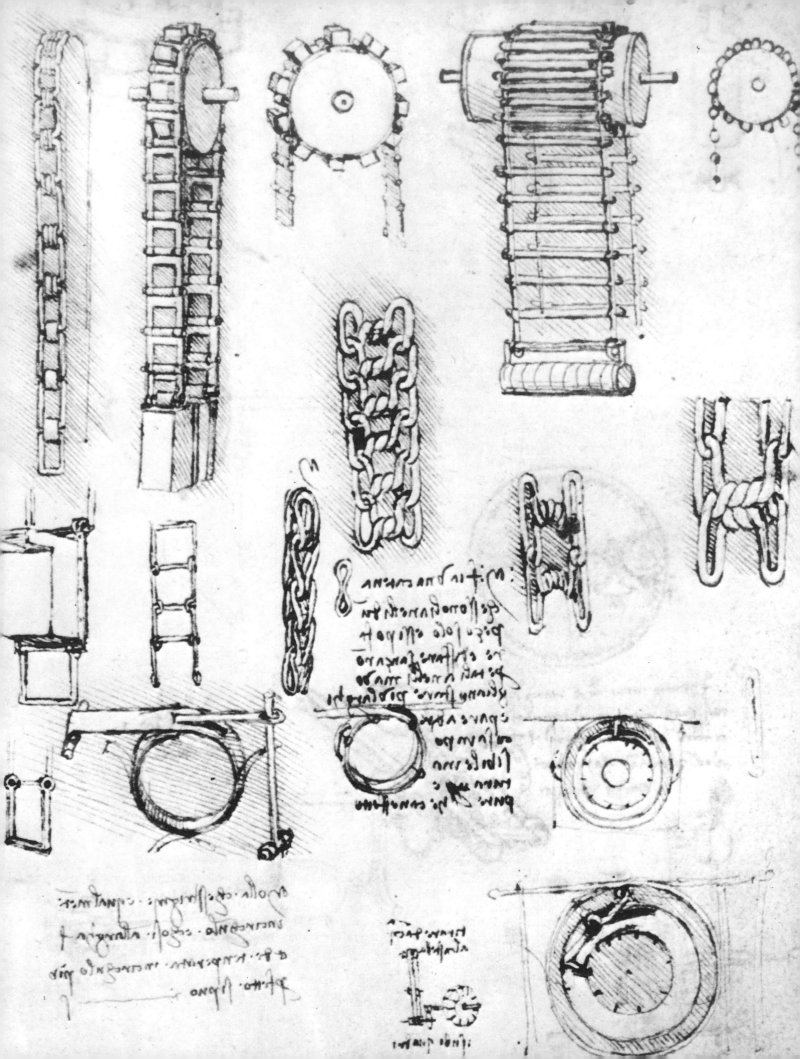

51. OPPOSITE *Chain drives and sprocket wheels*

RIGHT *Model of chain-link drive*

Chain drive is an extremely important mechanical device for power transmission yet it was absent from the technology of the western world until the eighteenth or nineteenth century. These drawings illustrate conclusively that the chain drive developed by Vaucanson in 1770 was not quite new – Leonardo had depicted it nearly three hundred years earlier. It is not possible to say from these drawings what practical application Leonardo intended for his chain drive, but he drew elsewhere a hinged chain-link for a wheel-lock for a gun. A complete chain drive assembly is illustrated in the little drawing at the bottom of the page.

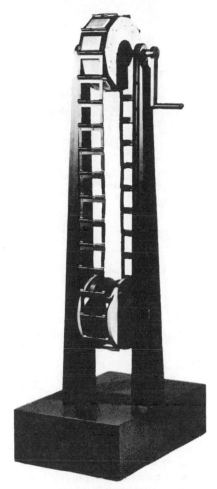

52. BELOW *Chain-links and tension springs*

The remarkably clear chain-links of various types illustrated here were probably intended for the wheel-lock of one of Leonardo's great interests: the breech-loading gun (Fig. 29). This is indicated by the juxtaposition of chain-links and tension springs. They clearly anticipate the articulated chains developed in the nineteenth century on bicycles and to drive machinery. It was not certain what uses Leonardo had in mind for chain-links until the discovery of the *Codex Madrid* in 1967 when numbers of drawings of chain-drive came to light. It is tempting to believe that Leonardo even considered the chain-driven bicycle since an indistinct and probably copied drawing of a bicycle came to light during a recent restoration of the *Codex Atlanticus* (Fig. 83).

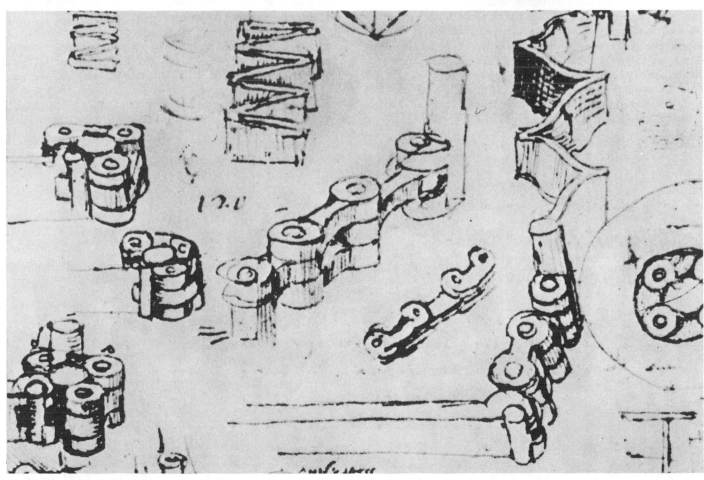

53. LEFT *Water turbine*

This drawing is capable of two interpretations, but both indicate how far advanced was Leonardo's thought in hydraulics. The drawing is of a water turbine, but what is not clear is whether it is being turned by the water (deriving energy from it like a waterwheel) or whether it is turning the water (applying energy to it like a ship's propeller). The implications of both theories are impressive.

If the turbine is deriving energy from the water passing over it, it is the forerunner of the modern water turbine, used for example in electricity generation. Leonardo used an airscrew in his automatic roasting spit (Fig. 61), so why not a hydraulic screw to power machinery with the turbine's spinning axle?

If, on the other hand, the turbine is turning the water, it is a forerunner of the centrifugal pump. In *Manuscript F* Leonardo illustrated such a pump for swamp drainage. Turned by a crank in its axle, the turbine whirled the water around in an enclosed well. Centrifugal force pushed the water upwards and out of the well, thus draining the land around it.

Both theories are consistent with the drawing, so Leonardo left us a choice of interesting explanations.

54. BELOW *Variable-speed gearing device*

This forerunner of the modern car gearbox comes from a page of sketches showing different types of gearing. It is one of the most ingenious types of power transmission devised by Leonardo, and it is not hard to imagine uses for it in his day. For example, water-powered machinery could be run in whichever of the three gears was most appropriate for the quantity of water turning the wheel on a particular day. By meshing three gear wheels of different diameter with the same lantern wheel different speeds of rotation could be obtained. If it is assumed that the prime mover is turning the lantern wheel, then the fastest running would result from engaging the top or smallest of the three gear wheels while the slowest running would result from engaging the bottom, largest gear wheel.

55. OPPOSITE *Air turbine*

This drawing shows a series of toothed wheels, gears and axles being driven by compressed air. Large bellows, powered by a mechanism not illustrated, are directed towards the edge of a turbine wheel which reacts to the twin jets of air to turn various axles and gears. The turbine wheel resembles the waterwheel in that the air is directed to pockets around its outer rim.

Since it is not possible to say what is driving the bellows, the device is really a form of transmission rather than a prime mover. Were it possible to overcome the friction of gearing to drive machinery in such a way, it would certainly start and accelerate more smoothly than a direct-drive transmission; however, it remains difficult to imagine any applications for such a device.

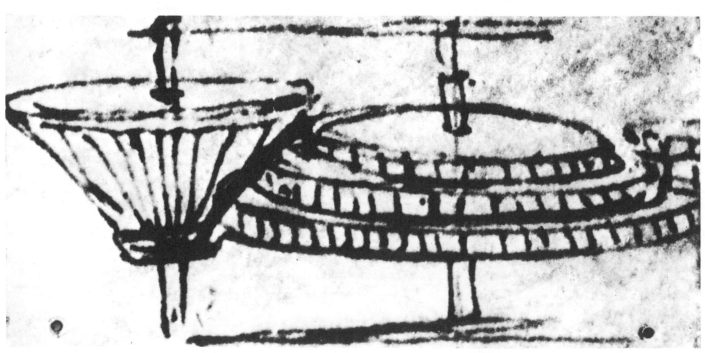

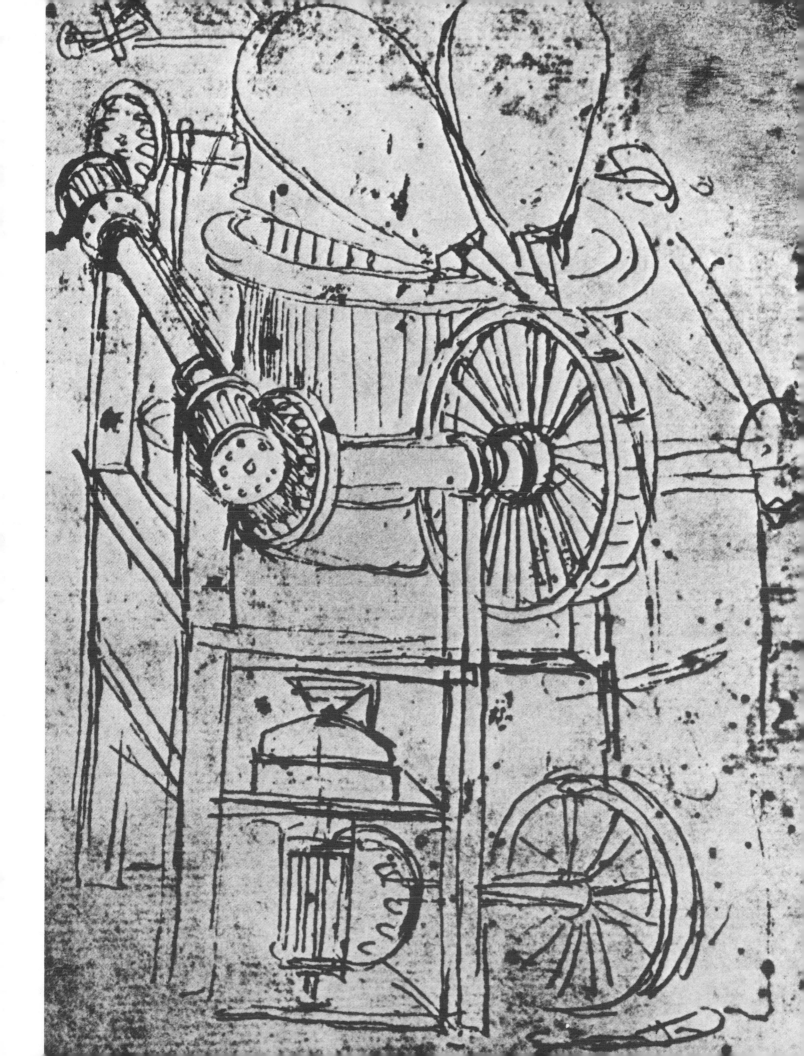

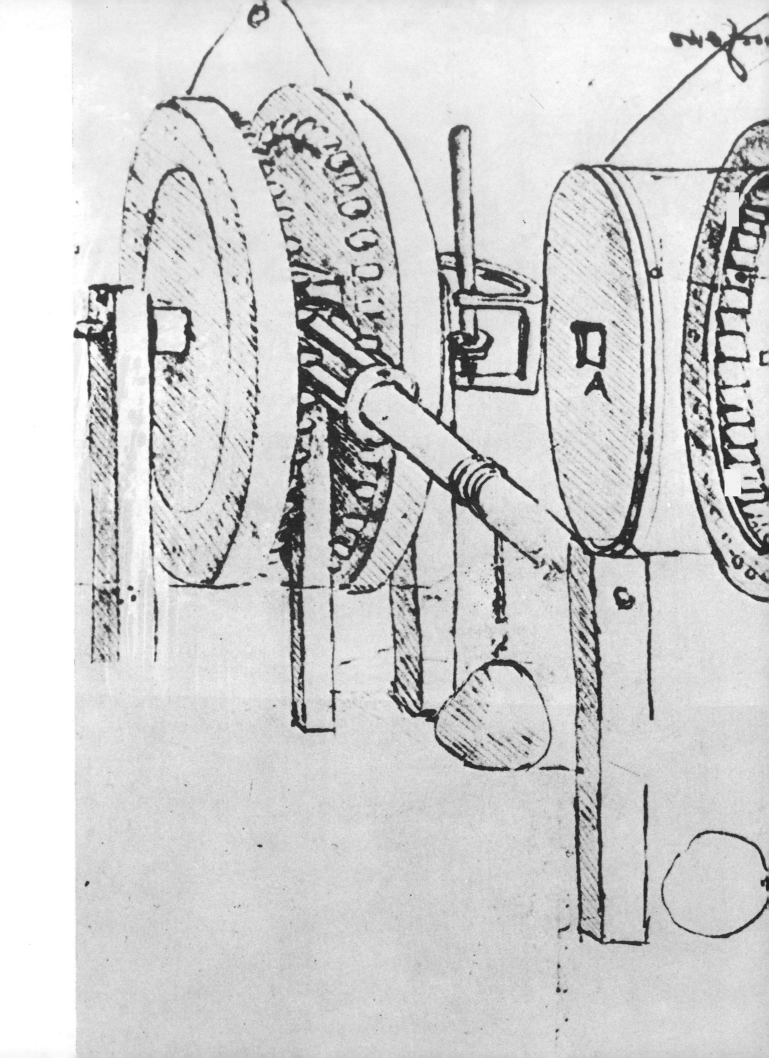

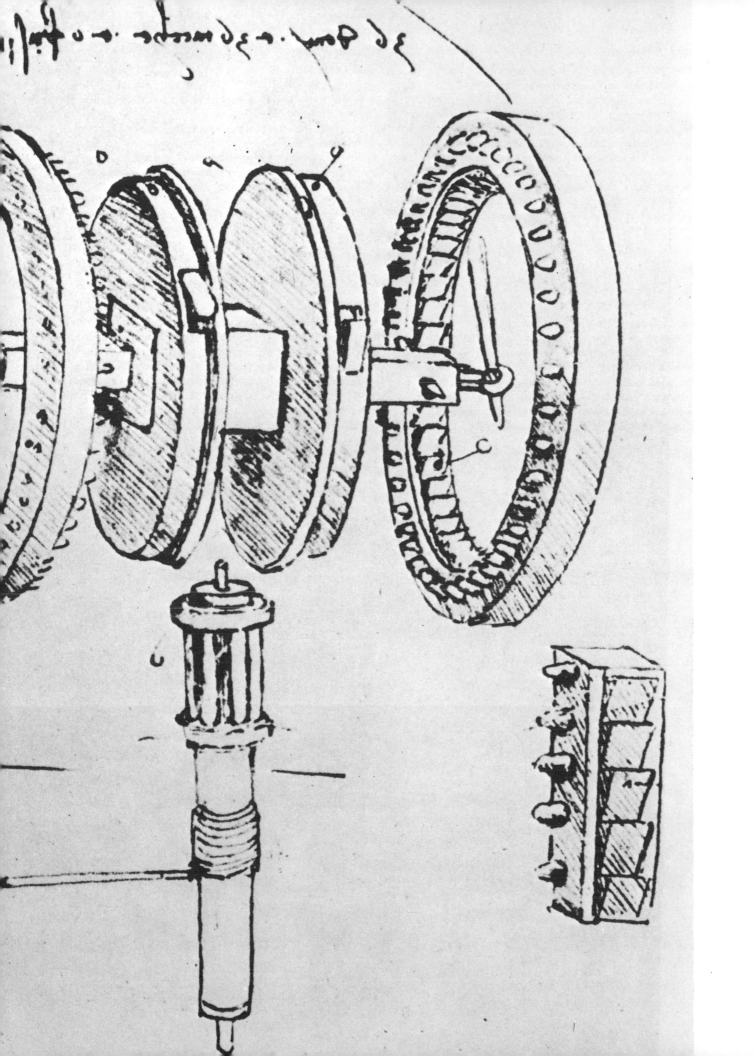

56. OVERLEAF *Reciprocating to rotary motion*

This drawing represents on the left an assembled, and on the right an exploded view of a mechanism for changing the rocking motion of an upright lever (on the right of each view) to the rotary motion of a shaft, so as to lift a heavy weight. The drawings are outstanding not only in their novelty of assembly but in their clarity, especially the exploded view. The operating lever is rocked back and forth and the stone suspended by a rope is wound upwards around the horizontal shaft. The rocking lever swings a square shaft, upon which are fixed two wheels, each having pawls in their outside edges, acting in opposite directions. The pawls engage ratchets in the bores of two outer rings. These ratchet wheels also have gear teeth engaging a common lantern gear on the final shaft. When the operating lever is pushed one way, one of the pawls engages its ratchet wheel. When the lever is pushed the other way, the other pawl engages its ratchet wheel, but the shaft revolves in the same direction. The mechanism could be used for a windlass, hoist, or in several schemes Leonardo had for automotive vehicles (Fig. 82). It certainly provides a practical link between reciprocating and rotary motion. One application of the principles is to be found in Leonardo's own work, an illustration of a paddle-driven boat worked by treadles also in the *Codex Atlanticus* (Fig. 77).

57. BELOW *Gimbal-ring suspension*

This is one of at least two drawings by Leonardo of a device which was to have an enormous practical application in marine navigation. If the ship's compass were mounted on the inner ring it would remain horizontal against the rolling and pitching of the vessel at sea, since each of the rings can rock in a different plane. Thus the compass was insulated from the motion of the sea.

Gimbal ring compass mountings appeared on ships in 1571, almost a century after Leonardo's drawings. However, there is no doubt that Leonardo had envisaged the marine use of gimbals: in the *Codex Madrid I* is a small drawing of a slightly more complex structure than the one illustrated with the words 'method of making rings that can turn in every direction such as the mariner's compass'. It is perhaps interesting that while Leonardo clearly understood the properties of the compass lodestone, he thought that the magnet was attracted by the Pole Star and not, as was subsequently discovered, by the earth's magnetic field.

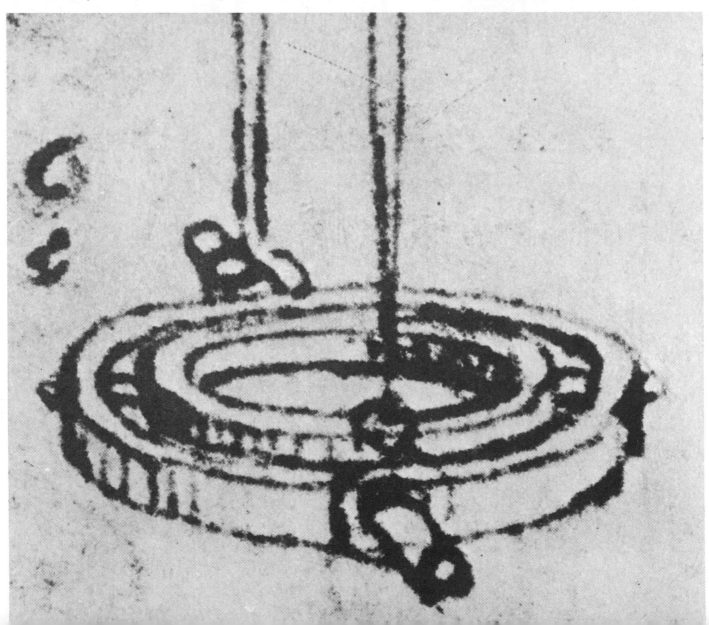

Leonardo noticed that accuracy in clocks depended to some extent on weather conditions. Both temperature and humidity could influence escapements – clocks tended to run slower when humidity was high, for example. So Leonardo began to think about making use of air resistance to slow down certain aspects of the mechanism deliberately. The result was a device called the fly for slowing down the unwinding of springs or descent of weights. It was simply a revolving axle with vanes that used air resistance as a regulator. Small adjustments to the number and size of these paddle-like vanes could be used to alter the speed of rotation of the axle.

The two-vaned fly illustrated is intended to slow the fall of the weight driving a clock-striking mechanism. The fly is turned first one way then the other by a quadrant rocked by a pin travelling the groove in the outer edge of a wheel turned by the falling weight. Leonardo seems to have been interested in the characteristics of various types of fly. Alongside the illustration of the four-vaned fly he writes, 'which fly will in its revolution resist the percussion of the air more, a fly of two vanes or one of four or eight?' He concludes in favour of the two-vaned fly because the four-vaned fly 'resists less against the wind because the progress of its motion is continuously facilitated.'

In some large types of clock the fly is still used in striking mechanisms.

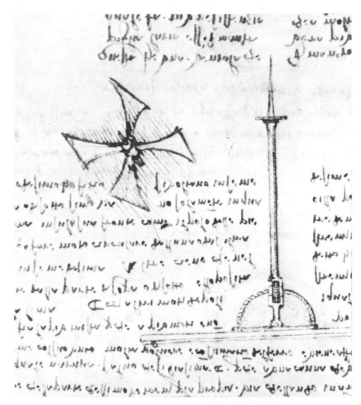

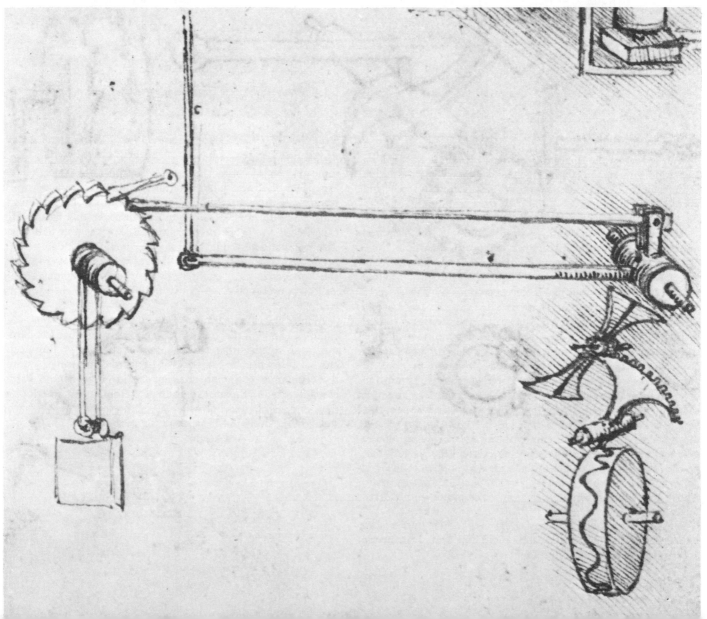

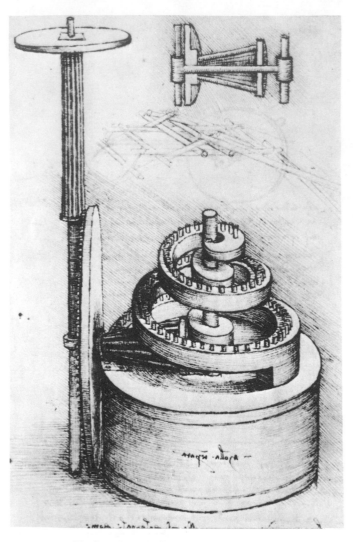

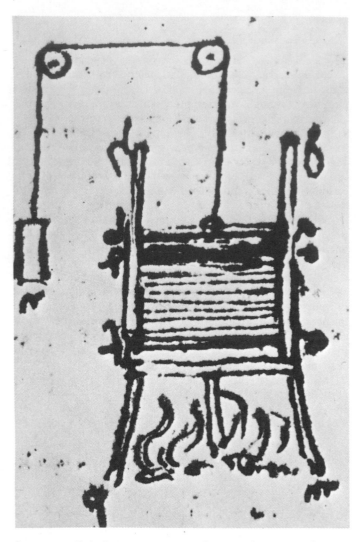

59. ABOVE *Clock spring equalizer*

The discovery of the *Codex Madrid* has thrown a lot of light on Leonardo's interest in clocks. He lived at a time when the design of mechanical clocks was undergoing steady improvement and horology, perhaps because of the great size of public clocks, was a field of opportunities for the mechanical engineer.

This drawing represents one of a number of suggested improvements to the fusee. Just before Leonardo's time, clockmakers were beginning to use the spring as an alternative to falling weights to power clocks. The tendency for springs to lose power as they unwind had been overcome by the fusee, a fifteenth-century invention that parcelled out the force of the spring evenly as it ran down. It usually consisted of a conical drum that slowly fed catgut or chain to the unwinding spring. Its great shortcoming was the tendency for the gut or chain to stretch or snap, and this encouraged Leonardo to think of alternative ways of equalizing the force of the spring as it ran down. The drawing is one of at least three very similar attempts to design a conical equalizing device directly geared to the spring which is contained in the barrel which forms the base of the mechanism. As the pinion climbs the slowly revolving cone of gear teeth, its axle slides up the spring axis and the vertical shaft on the left. Thus the power of the spring, as applied to the long lantern gear near the top of the vertical shaft, is kept constant. Above the main drawing is a section of the pinion and its fixed but sliding axle.

Whether it would have worked is not known but it is an interesting example of Leonardo's mind and draughtsmanship applied to a contemporary problem.

60. ABOVE *Calorimeter, to measure the expansive power of steam*

Although steam power and hot air meant very much the same thing in Leonardo's time, he designed an apparatus for testing the expansion of steam. Under normal conditions steam occupies 1,700 times the volume of the water from which it is produced, and Leonardo must have set out to discover this figure. His experiment was crude: a very thin calfskin bag was half filled with water and heated inside a square container open at the top. A flat board, fitting the sides of the vessel, was put over the bag and connected to a counterweight whose movement would indicate 'how much water grows in bulk when it is changed into steam.'

A few pages on in the *Codex Leicester*, the rope and counterweight are replaced with a rod, indicating that Leonardo was close to inventing the piston and cylinder of the steam engine. It has been suggested that Leonardo's drawings contain the beginnings of the steam engine, and Huygens and Papin certainly made similar expansion experiments in developing their engines. Leonardo made use of the sudden expansion of steam in the design of his steam cannon (Fig. 36).

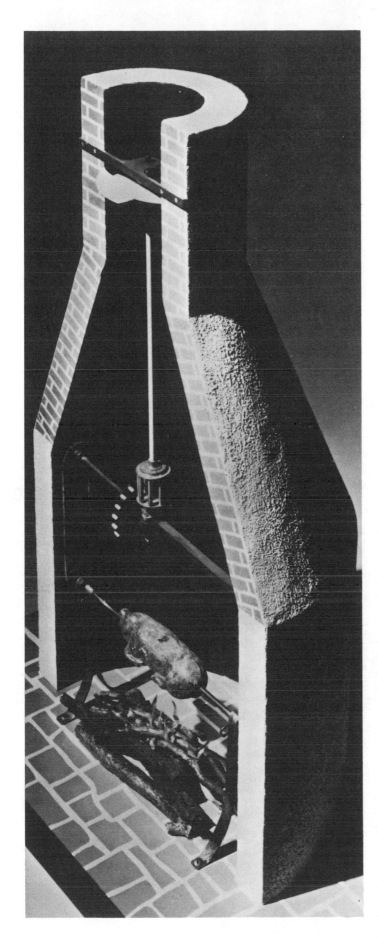

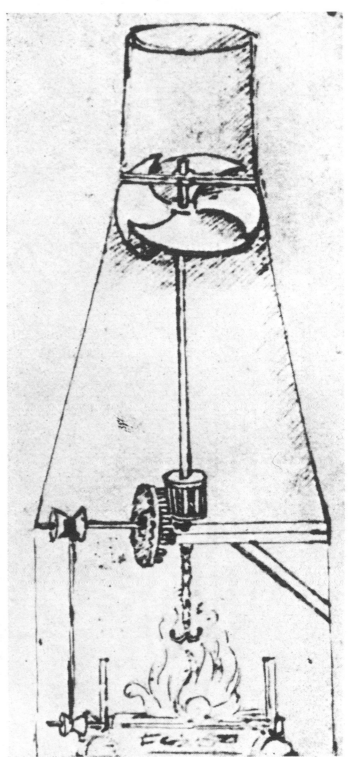

61. ABOVE *An airscrew-operated smoke-jack to work a roasting spit*

LEFT *Model of automatic spit*

This automated roasting spit has the virtues of simple design and practical application. Leonardo may not have invented this device but he shows understanding of the action of the airscrew deriving energy from the draught produced by the fire. Meat would have been speared on the spit in front of the fire, while a belt, pulleys and a crown and lantern gear transmitted motion down from the airscrew. The machine's simple efficiency lay in the fact that in Leonardo's words 'the roast will turn slow or fast depending on whether the fire is small or strong,' since a hot fire produced a strong draught and thus a more evenly browned, fast-revolving roast.

62. LEFT *Archimedean screws for bringing water to the top of a tower in two stages*

The extent of the general knowledge at the time of Leonardo about the raising of water was considerable. Designs were handed down by Vitruvius, and can be found in Alberti, Francesco di Giorgio and Giuliano da Sangallo. Verrocchio, an experienced hydraulic engineer, was responsible for bringing knowledge of and an interest in the subject to Leonardo.

This arrangement of two Archimedean screws for bringing water in two stages to the top of a tower is characteristic of Leonardo's ability to add to known technology. But there is more than the hand of a visionary engineer in this drawing; his abilities as an artist and architect are added to produce a drawing of something whose function and workings are immediately clear. The waterwheel turns the two screws which fill the water tower and thus provide a head of water for, perhaps, a town's water supply.

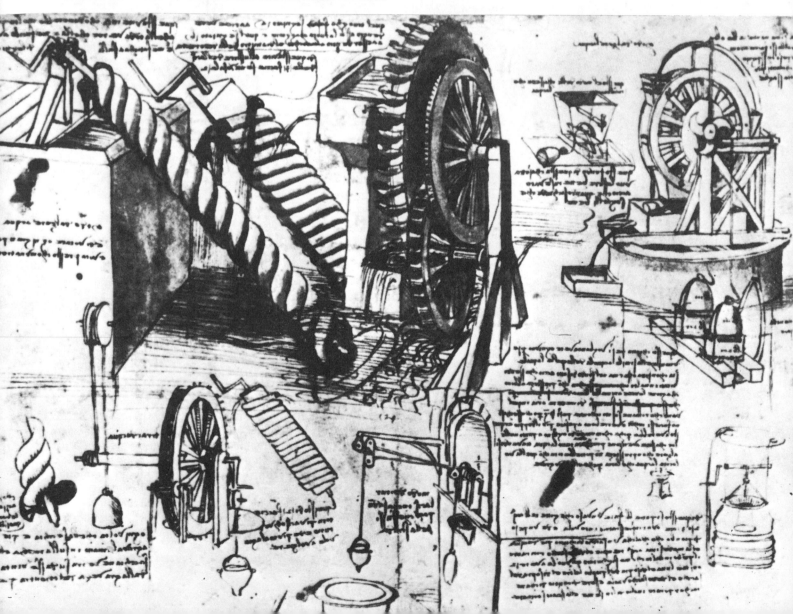

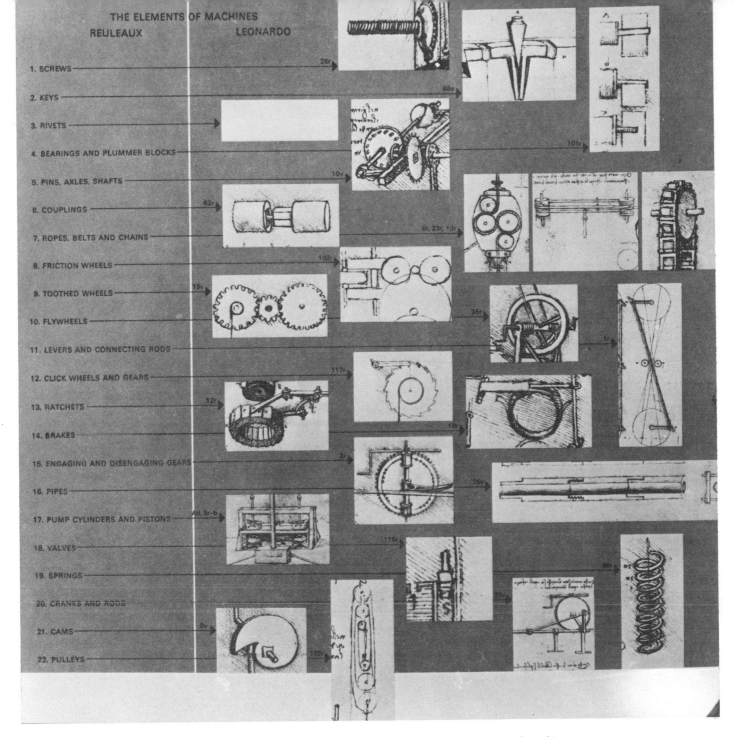

THE ELEMENTS OF MACHINES

REULEAUX LEONARDO

1. SCREWS
2. KEYS
3. RIVETS
4. BEARINGS AND PLUMMER BLOCKS
5. PINS, AXLES, SHAFTS
6. COUPLINGS
7. ROPES, BELTS AND CHAINS
8. FRICTION WHEELS
9. TOOTHED WHEELS
10. FLYWHEELS
11. LEVERS AND CONNECTING RODS
12. CLICK WHEELS AND GEARS
13. RATCHETS
14. BRAKES
15. ENGAGING AND DISENGAGING GEARS
16. PIPES
17. PUMP CYLINDERS AND PISTONS
18. VALVES
19. SPRINGS
20. CRANKS AND RODS
21. CAMS
22. PULLEYS

63. OPPOSITE *Well pumps, waterwheels and Archimedean screws*

The miscellany of methods of raising water depicted here is typical of the way Leonardo refined known technology. There is nothing original in concept about any of the drawings, but they all show refinements of existing primary-power wheels or novel ways of applying them. A good example of this is Leonardo's version of the Archimedean screw: in the classic version a screw fitted tightly into a long cylinder with the water lifted in the spiral channel thus formed. Obviously there was much friction and seepage in such a device. Leonardo's version was a hollow tube spiralled around the outside of a long cylinder – at the correct angle the water would come up this exterior tube.

Possible uses for the screws and the well pump illustrated here were in swamp drainage and water supply.

64. ABOVE *The elements of machines*

This tabular depiction of the elements of machines is reproduced by kind permission of the publishers of *The Unknown Leonardo*. It shows that Leonardo appreciated all the elements of machines as listed by Franz Reuleaux in *The Kinematic of Machinery* in the nineteenth century when industrialization, not foreseen by Leonardo, had become the driving force of the age, and machinery of all sorts was central to life. It shows that over 400 years before its invention, with the exception of rivets, all the elements of the internal combustion engine, for example, could be found in Leonardo's works despite the relative crudity of materials in his day. Industrialization has made Leonardo's mechanical engineering drawings much more significant than if the world's development had not moved in such a direction, but it cannot be denied that many of the blue-prints of modern machinery are to be found in the works of one man over 250 years before the first industrial revolution began.

Water

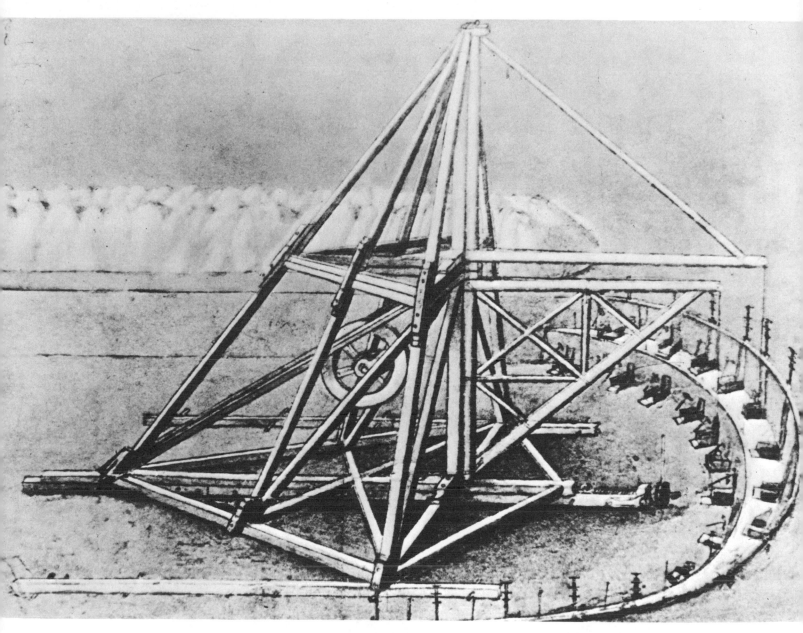

65. *Treadmill-powered digging machine*

Leonardo probably designed this machine having in mind the Florentine scheme to divert the River Arno by means of canals. This ambitious project, which Leonardo suggested, was abandoned, and the river has continued to threaten Florence down to modern times.

Since Leonardo proposed to dig canals on a vast scale – up to 60 feet wide and 21 feet deep, the labour costs were likely to be prohibitive unless spectacular mechanical assistance could be provided. This machine was designed to ease the most laborious aspects of canal construction by both digging and carrying away the dirt from the trench. It was mounted on three parallel rails, its central column having two derrick cranes, one above the other, and able to swing through 180 degrees. Digging advanced on a broad front at two levels. It has been suggested that the telegraph-pole-like devices on the rim of the digging were stab-diggers dislodging soil at each blow into buckets which, when full, were carried off by the cranes to adjacent spoil tips. The cranes, and presumably the stab-diggers, were powered by a treadwheel and the whole structure could be moved forward by the screw winch projecting from the centre rail.

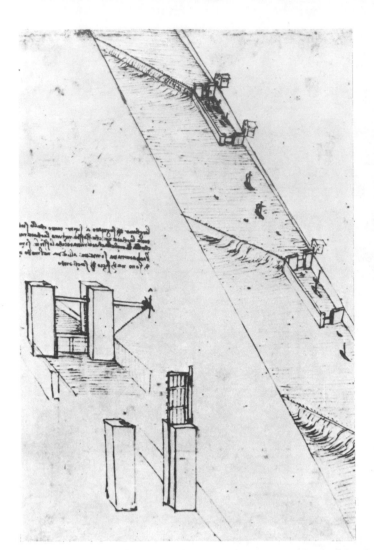

66. LEFT *Canal with locks and weirs*

This well executed drawing, which dates from 1480–5, shows how a canal might change levels. The canal (or navigable river since it seems to be flowing) has two sets of locks built alongside weirs; and boats are shown negotiating the locks, beside which lockkeepers' houses stand. To the left of the main drawing the system of gates is illustrated.

The lock-gate is probably of fifteenth-century Dutch origin. Leonardo became involved with canals and locks in the spate of European canal building of the second half of the fifteenth century. He was consulted officially about canal engineering and even designed a canal to link Milan to the sea. When he arrived in Milan in 1482 he studied the canal system as envisaged by the ruling Visconti family earlier in the century. He noted that the locks were of a portcullis type which were hoisted above passing boats. The locks illustrated here are of this type but with a major modification: once winched up to the horizontal shaft, the sluice boards could slide sideways into their supporting pillar, thus offering no height restriction to sailing vessels.

Leonardo later invented pairs of hinged gates that met at an angle pointing towards the higher reach, a watertight joint resulting from the pressure of water on their mitred edges. Six locks were actually built on this design by 1497 and it remains in common use.

67. BELOW *Floating dredger*

Leonardo designed various types of dredging machines for removing sludge and silt from canals and navigable rivers. This 'instrument for excavating the earth' is mounted between two barges from which it derives its stability, rather like a modern catamaran. A crank or winch is used to turn a toothed wheel on an axle about which a battery of four scoops rotates to pick up in succession loads of sludge which are carried round to be deposited into a barge. A stake tethers the barges in position and enables them to be pulled forward to the next point of operation.

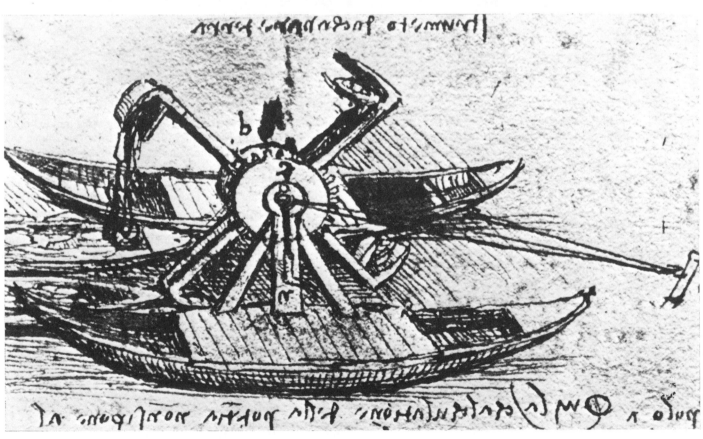

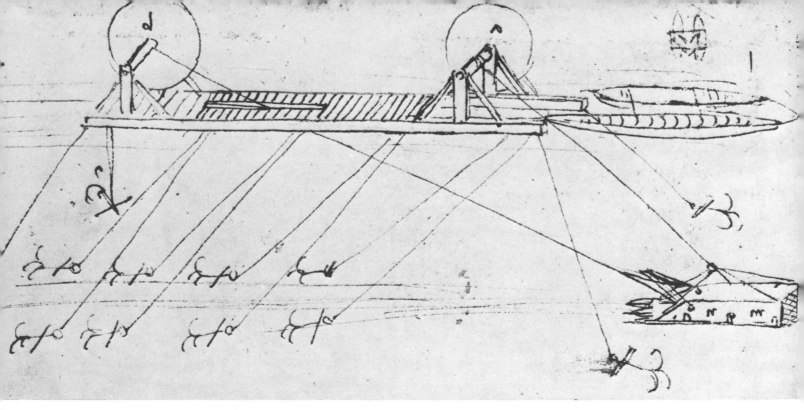

68. TOP *A harbour dredger*

BELOW *Model of harbour dredger*

This simple drawing shows how Leonardo envisaged deep dredging on a large scale. The simple device illustrated previously could have coped with canals or rivers used by barges drawing a few feet of water, but ocean-going vessels, even in Leonardo's day, might have drawn up to fifteen feet, and therefore a more substantial dredger was needed for harbours and quays, especially in the almost tideless Mediterranean.

The long dredger was secured to the bottom by a number of anchors sufficient to hold it against the drag of a large box-like bucket. This has spikes in front of its open end, similar to plough-shares and knives, and a perforated back to allow water through. The 'plough', as Leonardo called it, was then dragged over the place where mud was to be dug out. The windlass at the left-hand end of the dredger on the drawing (labelled 'b' in mirror writing) would then drag the plough until it was under the other windlass ('a' in mirror writing), which would lift the plough out of the water where it could be discharged into a barge.

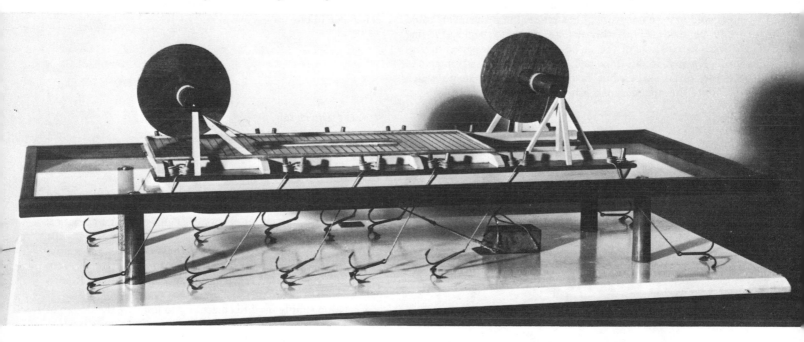

69. ABOVE *Fishes and ships' hulls compared*

Up to the last days of wooden shipbuilding in England it was commonplace among shipwrights that a hull should have 'a cod's head and a mackerel's tail.' Indeed there are drawings of fish-form underbodies of merchant ship designs in early works of naval architecture, for example in Matthew Baker's notes.

For Leonardo, two centuries earlier than Baker, the study of nature was the point of departure for any research. If the natural principles which underlie everything, even mechanical engineering, could first be uncovered, then rational improvements could easily be made. Thus the obvious place to begin studying hydrodynamics was in the shapes nature had designed to pass through water. In this drawing Leonardo infers disadvantages in the top three shapes but favours the bottom shape which resembles the side view of a fish.

70. ABOVE *Floats for walking on water*

This self-explanatory drawing of a man walking on water with buoyancy from shoes and sticks is a good example of Leonardo's refusal to be confined by what then appeared to be the laws of nature. If flight and life underwater were theoretically possible to Leonardo then why not walking on water? The posture and equipment of this renaissance amphibian are highly reminiscent of modern-day skiing, but Leonardo was not thinking of a leisure pursuit in this drawing, rather of the military implications of being able to cross water barriers.

71. LEFT *Diving suit*

OPPOSITE CENTRE *Model of diving suit*

72. OPPOSITE TOP LEFT *Snorkel*

73. OPPOSITE TOP RIGHT *Life preserver*

Diving and diving equipment had been a preoccupation of inventors long before Leonardo took up the idea of enabling man to move and act freely under water. Fantastic but impractical diving bells were common in the works of his predecessors, while diving suits appear in both Kyeser and the *Anonymous Manuscript of the Hussite War* in the late fourteenth and early fifteenth centuries. Alberti used Genoan divers to raise sunken Roman galleys in Lake Nemi in 1447.

Leonardo simply used his ingenuity to improve the design of diving equipment with results that are sometimes quite modern in appearance. For example, the design for a lifebelt illustrated at top right is quite modern in itself, but just above it (not illustrated) is a design for webbed gloves just like a frogman's flippers.

The main intention behind Leonardo's diving suits was warlike – the diving suit (Fig. 71) accompanied a device for

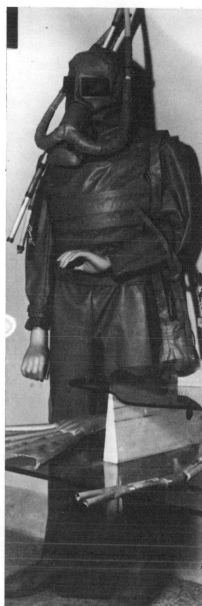

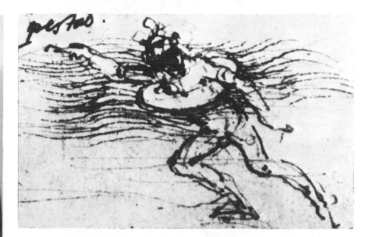

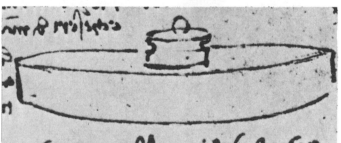

74. ABOVE *Double-hulled and semi-submersible boats*

This drawing is a good example of Leonardo's ability to produce designs for offensive and defensive war technology that could almost be said to neutralize each other. Above is a 'ship to be used to sink another ship', a shell with room for one person to crouch in with a primitive conning tower and lid to close it. It predates the first navigable submarine by a hundred years. On the right is the means of defence against underwater attack. The double-hulled ship could meet the threat of enemy ramming action or interference by divers. It had double planking separated by an air space, and Leonardo advocated this type of construction for ships generally for their 'safety in time of war.' After all, in the *Codex Atlanticus* is a device with which divers could spring planks of enemy ships from underwater.

holing enemy ships. The suit consists of coiled armour plate under a sealed tunic to prevent the chest from compression. Elsewhere he designed a combination suit of boots and trousers even containing a built-in 'convenience'. A breathing apparatus is illustrated above: a floating dome of cork contains air ducts from which strengthened tubes lead down to an intake/expiration valve.

Reconstructions of these designs in the Milan Science Museum are not only modern in appearance but are thoroughly practicable.

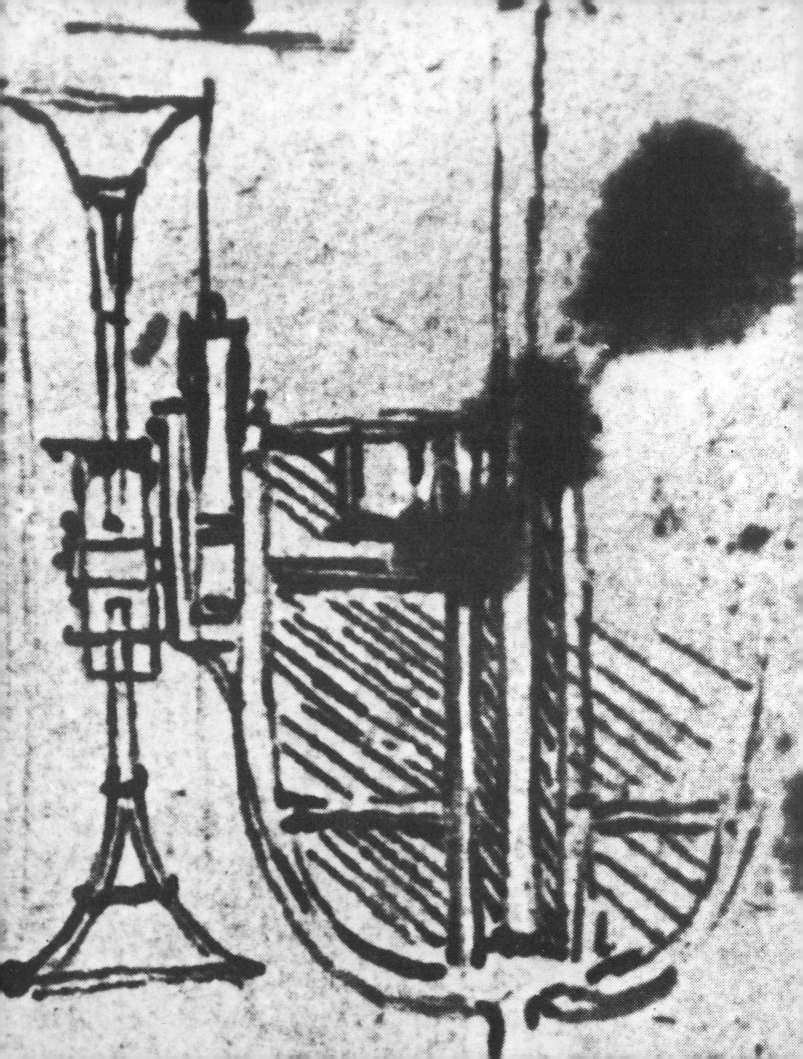

The lack of an easily controlled prime mover (such as the modern internal combustion engine or electricity) was felt acutely by Leonardo in such areas as the propulsion of boats. Leonardo could have had no real concept of alternatives to muscle, wind or water power, so he experimented with ways of harnessing them more efficiently. The strategic implications of enabling a boat to move independently of the wind were considerable, and many designs for the mechanical propulsion of boats appear in the *Codex Atlanticus* and *Manuscript B*.

Here Leonardo illustrates a small boat of a type familiar to children, the hand-cranked paddle boat. The paddles themselves are shovel-shaped and (unlike the oarsman in a rowing boat) the operator can see where he is going. This boat forms a basic design from which Leonardo elaborated.

76. OPPOSITE *Crank-operated paddle boat with flywheel and gearing*

BELOW *Model of paddle boat*

This drawing dates from 1495–1500 and shows Leonardo's steady advance beyond the thinking of Taccola, Valturio and Francesco di Giorgio among others, all of whom included paddle boats in their military manuscripts.

It shows a cross-section of a crank-operated paddle boat, one of a larger number of similar drawings that cover a page of the *Codex Atlanticus*. The shovel-shaped paddles are turned by an inboard crank connected to which is a large flywheel to ease the dead spots in turning the crank. Since the flywheel clearly divides the boat in half, another crank would have driven the other paddle wheel. Moreover, gearing between the crank and the paddle wheel axle enables the paddle wheel to turn faster than the crank. This gearing can be seen clearly in the reconstruction of such a vessel without the flywheel.

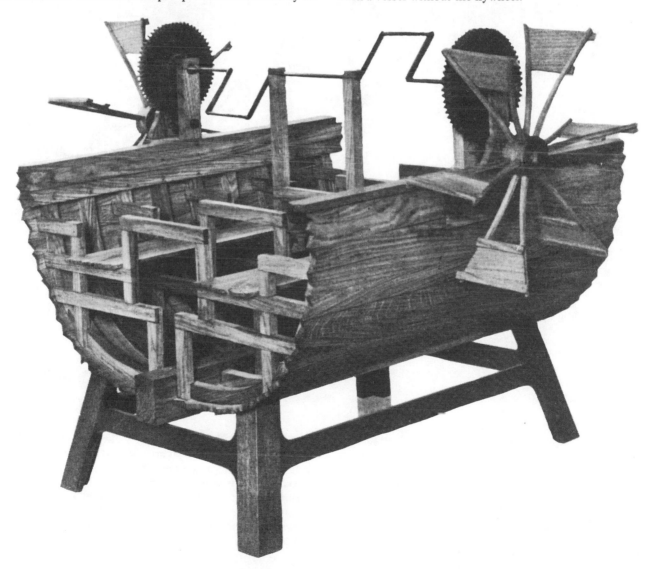

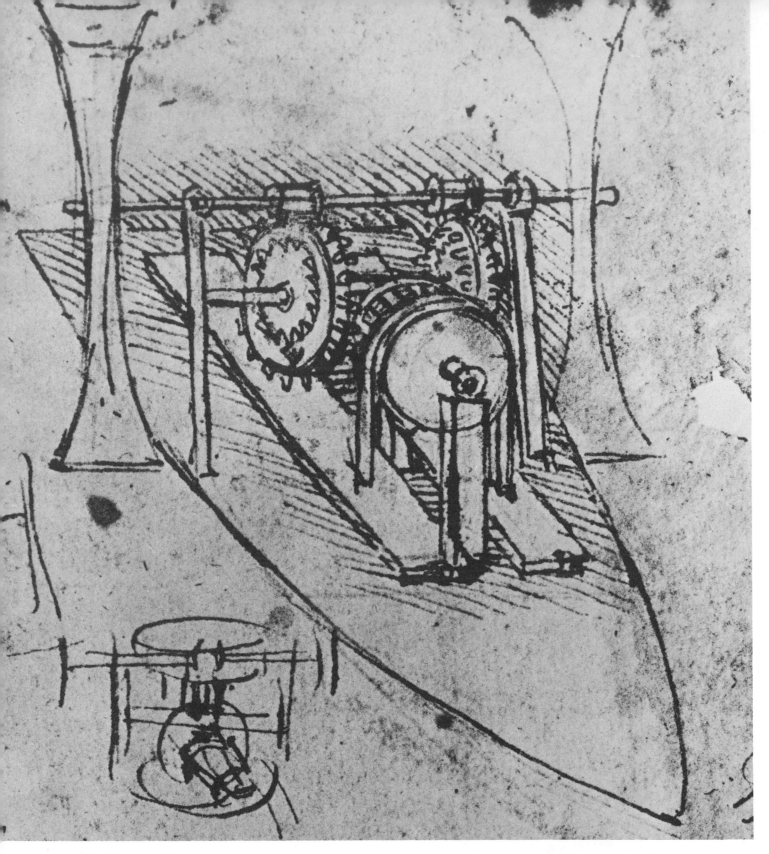

77. *Treadle-powered boat*

Elsewhere in the *Codex Atlanticus*, Leonardo illustrated an ingenious method of transferring reciprocating to rotary motion – turning a windlass by rocking a lever (Fig. 56). On this large boat design, the same mechanism is used to enable a pair of treadles to turn paddle wheels – a good practical application.

As the treadles are alternately depressed and raised, they operate a belt around a central drum which is geared to toothed wheels which drive the paddles. Ratchets incorporated in the toothed wheels ensure that the paddles always revolve in the same direction. No indication of scale is given, but the skills required to operate the boat are minimal – the transfer of weight from one treadle to another. With a steering device, a vessel powered in this way could have been useful in a seaborne offensive, being able to operate regardless of wind conditions. It is, in effect, as far as Leonardo could go in applying his knowledge of mechanics to boat propulsion without a new prime mover.

Vehicles on Land

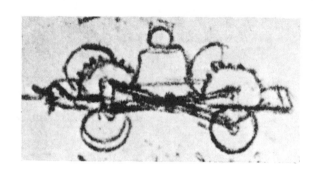

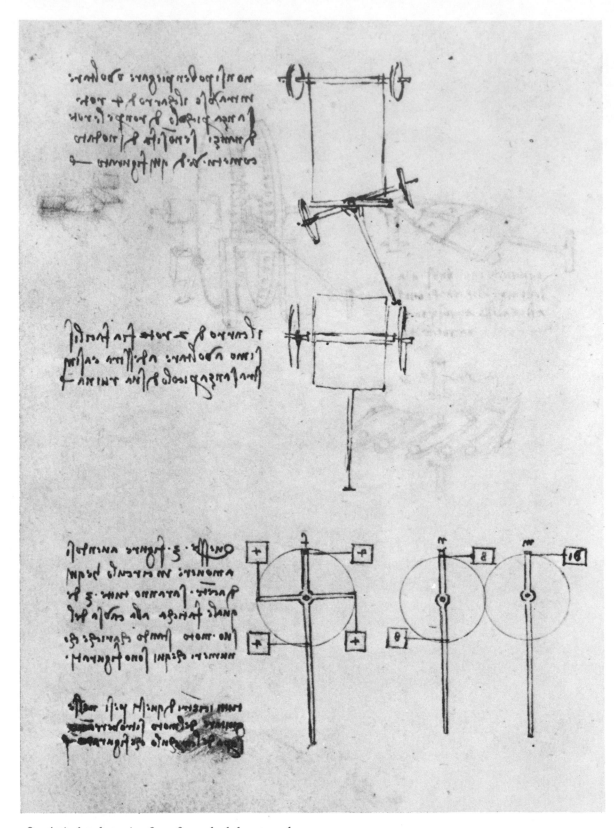

78. *Articulated steering for a four-wheeled cart, and a study of turning forces*

In the drawing of carts and their axles, Leonardo observes that while a two-wheeled cart can easily be turned to left or right, a four-wheeled cart requires articulation as illustrated. To try to turn such a cart without a movable axle risks breaking the front wheels.

In the lower drawings Leonardo studies the effects of turning forces of given quantities and concludes

that 'turning horizontally these three figures shall all burden equally their movers if loaded with the weights indicated.' (Four forces of four, two of eight and one of sixteen respectively.) These force diagrams presumably represent theoretical explorations of the effects of various forces in turning the axle of a two-wheeled cart.

79. ABOVE *Self-steering for a cart*

Having considered methods of and forces in turning two- and four-wheeled carts, Leonardo contemplated how to steer a cart whose direction was not determined by its motive force, i.e. the animal pulling it. In the tiller-steering illustrated, Leonardo has accomplished a considerable feat of abstract thinking, because there was no prime mover other than muscle power in the land transport of his day. This did not stop him from thinking through the problems of how to steer a vehicle that could move on its own: he was anticipating the horseless carriage.

80. BELOW *Transmission unit for the axle of a wagon*

No-one prior to Leonardo gave as much study to vehicles of all kinds – from armoured cars to horseless carriages. As with many of his drawings, he seems more concerned here to show details of particular components than to give an idea of an entire structure, as though he was thinking of writing an instruction manual.

The drawing depicts a transmission unit with a multiplying ratio for the axle of a wagon. The large horizontal toothed wheel turns the axle many times for each of its own revolutions, thus converting a slow action by the prime mover into a faster rate of movement at the cart wheels. Leonardo designed a similar transmission for turning millstones, with the addition of a handbrake.

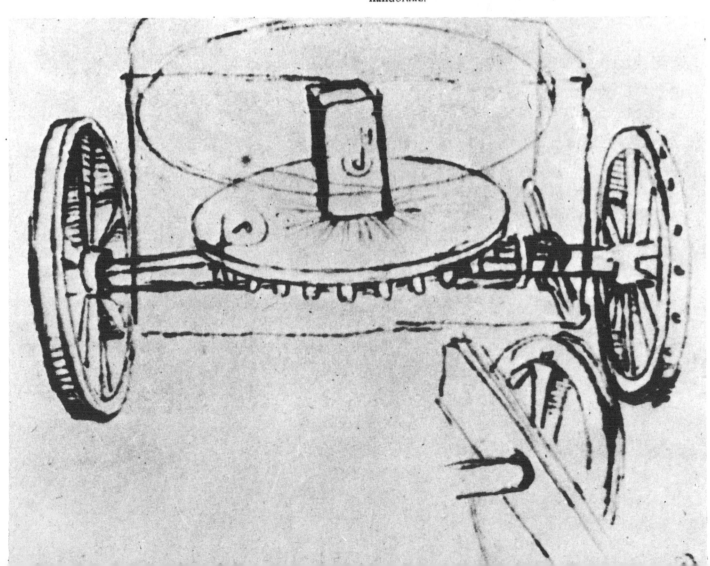

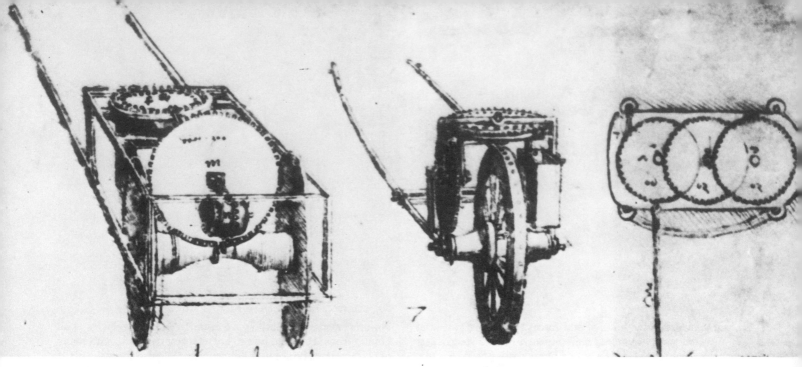

81. ABOVE *Two hodometers and a pedometer*

BELOW *Model of hodometer*

Seeking accuracy in all things, Leonardo investigated the measurement of surface distances. The drawing in the centre is of a 'waywiser' or hodometer based on an idea of Vitruvius. The wheel of measured circumference turned the horizontal wheel through various gears in such a way that each time it completed a revolution, a pebble would drop into the box. The number of pebbles was the measure of distance. The left-hand drawing is of Leonardo's improved design: here the gearing reduction is so large that the horizontal wheel turns only once for each mile covered. On the right, and based on the same principles, is a pedometer which would measure the number of steps taken by a man or horse by means of a pendulum resting on the thigh.

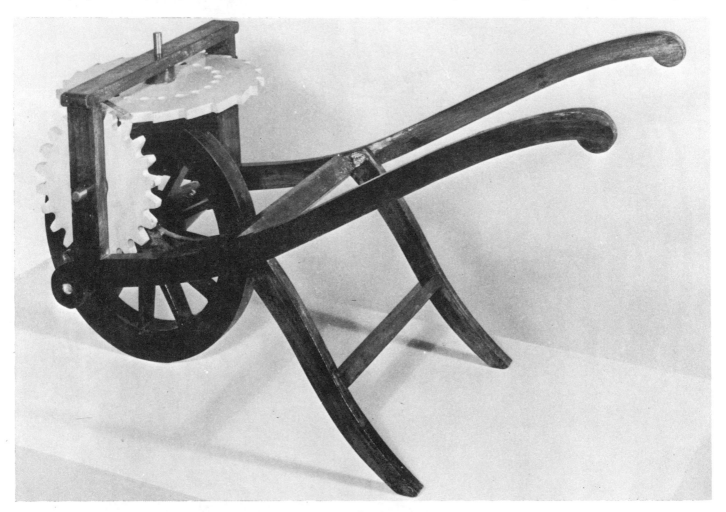

82. RIGHT *Automotive wagon*

BELOW *Model of automotive wagon*

A remarkable mental breakthrough is implicit in Leonardo's design for an automotive wagon, or horseless carriage. It is a light cart with three wheels under the body like a tricycle, with another wheel for steering ahead of the vehicle, controlled by a rudder. It differs from the many drawings of vehicles found elsewhere in his manuscripts in that it tried to accumulate the energy necessary for motion within itself, like a modern clockwork motor. By using the energy stored in a system of springs, the vehicle could move without muscle power. Although this makes it a forerunner of the motor car, it was really military in conception, since it could manage without horses which are vulnerable in battle.

The drawings make clear the transmission system, but not the springs. It is thought that the difficulties of connecting the springs to the driving wheels caused Leonardo to leave this part incomplete, but in the transmission is a remarkable innovation: the differential. By using independent transmission for each wheel and an epicyclic wheel arrangement, each driving wheel could work at slightly different speeds when turning a corner. Even early motor cars did not always have such a refinement.

Although the car came to nothing in practice, it reflects Leonardo's success in the search for at least the principles of a new form of propulsion.

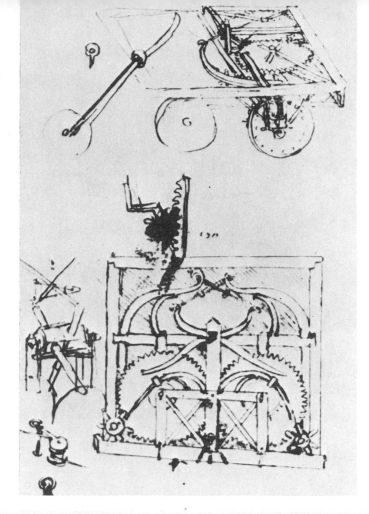

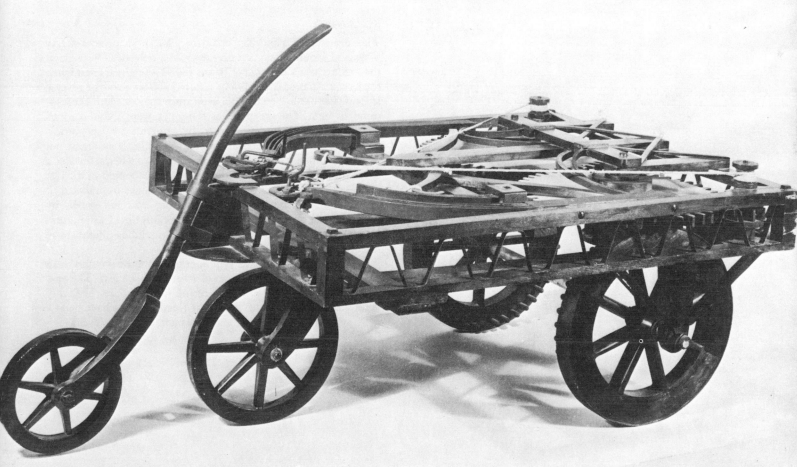

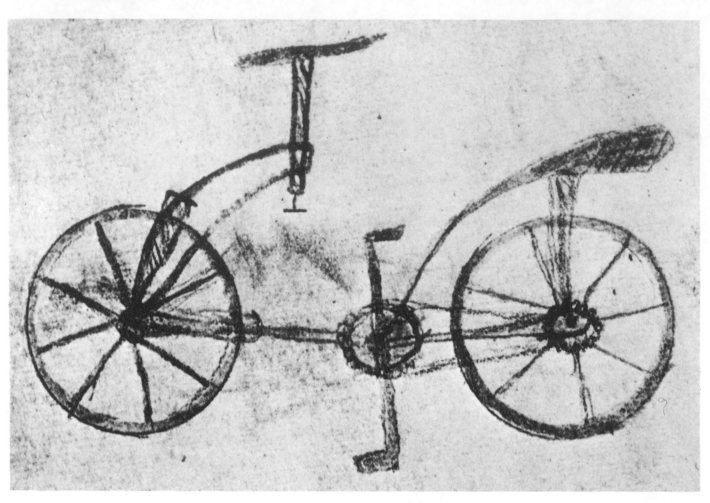

83. *A bicycle*

This drawing of a bicycle, not dissimilar in shape to a safety bicycle of around 1900 is a mystery and a revelation because of the manner of its discovery. It was found a few years ago when the *Codex Atlanticus* was being restored and some of the reverse sides of Leonardo's pages, not seen since the sixteenth century, came to light. On the back of folio 133 were found various youthful scribblings, apparently by students of Leonardo's studios in the early 1490s, including a bicycle. It assumes, not only that humans could actually balance on two wheels, but also a chain drive of a type almost identical to that adopted in the late nineteenth century. Although the steering looks impractical, it must be remembered that the drawing was not made by Leonardo but by someone who lacked his abilities as a draughtsman. Whatever he saw in Leonardo's studios might have resembled the modern bicycle still more.

The drawing is not just a reminder of Leonardo's vision as an engineer, but also an indication of what has been lost. The vast majority of Leonardo's engineering designs are probably irrecoverable, and among these lost treasures may have been a more sophisticated drawing and explanation of the bicycle.

Investigations of Nature and Designs for Architecture

84. *Sketches of four plants: 1506–8*

TOP CENTRE *Star of Bethlehem (Ornithogalum umbellatum L.)*

TOP LEFT *Crowfoot or Buttercup (Ranunculus)*

TOP RIGHT *Wood Anemone (Anemone nemorosa L.)*

BOTTOM RIGHT *Spurge (Euphorbia), and at the left its seed-vessels*

Like other branches of natural history, botany as a science goes back to Aristotle. His pupil Theophrastus described over 400 plants. In Roman times the two most important writers were Pliny the Elder and Dioscorides, the author of *Materia medica*, 'the most widely read botanical work ever penned', which deals, as its title indicates, with the medicinal properties of plants and which remained the standard authority for 1500 years. During the Middle Ages, in spite of the popularity of herbals and the contributions of Arab scholars, botanical science made little progress, and Leonardo's empirical approach made him the pioneer of modern botany. He also seems to have invented a so-called 'natural impression', i.e. a way of printing a pressed leaf, suitably treated, directly onto paper: such a 'natural impression' of a sage leaf has been preserved in one of his manuscripts. It is worth remembering that the microscope was not invented until a hundred years after his time.

85. *Sketches of two plants: 1506–8*

LEFT *A spray of Dyer's Greenweed (Genista tinctoria L.)*

RIGHT *A spray of oak-leaves with a cluster of acorns*

Unlike his medieval predecessors, Leonardo had apparently little interest in the pharmacological and nutritive properties of plants, but his notebooks contain many penetrating observations on plant structure and growth, particularly on the arrangement of branches and leaves (phyllotaxis) and on the germination and sap of flowers and trees. These observations go hand in hand with artistic ones – on the gradations of light and shade in leaves, on the colours of trees, on the shadows they cast: a kind of manual for the practice of landscape painting. In the two sketches on this sheet the scientist's notation and the artist's irrepressible admiration of the beauty of nature are well exemplified. In addition to the plants reproduced here Leonardo drew and painted the iris, the wild pear, the quaking grass, the dog rose, the sweet violet, the heath dog violet, the bulrush, the guelder rose, the blackberry, the arum lily, the reed-mace, the bur-reed, and others. The loving observation evident in these sketches is matched in the famous watercolours of his great contemporary, Albrecht Dürer.

86. *Two sketches of a crab:* c. *1481*

Leonardo was fascinated by the habits and symbolic associations of animals, and he imitated the ever-popular Aesop in inventing new fables. He also made thorough investigations in the field of scientific zoology, where he concentrated particularly on the anatomy and movements of the horse and on the flight of birds and bats. These studies had practical applications: the former in his designs for equestrian monuments, and the latter in his plans for flying-machines (Fig. 13).

It may well be that crabs excited Leonardo's curiosity by their unusual manner of moving. His rapid, lifelike sketch has brilliantly captured the most prominent characteristics: the hard carapace and the five pairs of jointed legs, including the strong pincers.

87. *Water cascading into a pool*: c. 1508–10

Sir Ernst Gombrich, to whom we owe a masterly study of Leonardo's researches into the forms of movements in water and air, has shown that 'this subject was central to Leonardo's thought. It concerned him as an engineer, as a physicist, as a cosmologist and as a painter.' In fact, Leonardo planned an extensive Treatise on Water and drew up various detailed programmes for it. His aim was to compile what Gombrich calls 'a complete encyclopedia of the forms of water and of currents'. As so often, theory and practice were closely intertwined, for Leonardo concerned himself with the building of water-mills, bridges, sluices, canals, with 'diverting rivers from places where they do mischief' and with countless other engineering projects.

88. ABOVE *Two sketches of rushing water being impeded by obstacles:* c. 1509–10

The obstacles are placed at different angles to the direction of the flow, and the resulting swirls therefore assume different patterns. These interlaced patterns bear a striking similarity to those of the braided hair of many figures in Leonardo's paintings and drawings. He himself drew attention to this similarity in a note written on a similar drawing: 'Observe that the motion of the water curls resembles that of hair, which has two motions, one depending on the weight of the hair, the other on the direction of the curls; likewise the water has its swirling eddies, depending partly on the force of the principal flow, partly on the motion of impact and rebound.'

Referring to Leonardo's writings on the subject, Sir Ernst Gombrich has said: 'The concept of turbulence, which Leonardo uses to describe the state when the normal flow is

upset, operates with the idea of randomization where the path of an individual particle becomes quite unpredictable. Not that he does not also study the forms taken by waves and vortices, but what interests him is that these are mathematical relationships of a complexity that often causes him to admit defeat. Leonardo is frequently quoted for his beautiful saying that mechanics is "the paradise of mathematics". A glance into the most elementary text-book of fluid mechanics will convince most of us that this branch is the hell of mathematics. The arithmetical and geometrical tools at Leonardo's disposal were utterly far removed from those he would have needed to fulfil the wildly optimistic hope with which he started out – the hope of completely mapping out and explaining any contingency in a field that still eludes such rigid treatment.'

89. OPPOSITE *A cloudburst over a valley:* c. 1506

'A storm breaking over a valley in the foot-hills of the Alps. In the foreground a low ridge of undulating hills with churches and trees. Then a plain on which is a walled town with domed churches and campaniles. Beyond it to the right the mountains rise sharply, to the left more gradually, forming a valley which is cast into deep shadow by storm clouds hanging over it, discharging their rain. Above the clouds are high peaks of the Alps in sunlight' (Kenneth Clark).

Leonardo incorporated many of his scientific investigations of, and preoccupations with, meteorological phenomena into practical hints for painters, dealing with the best ways of rendering light and shade, clouds, winds, rain and storms. In this drawing he demonstrates how theoretical knowledge has been absorbed into an act of artistic creation – a masterly sketch of a landscape bathed in sunlight and drenched with rain.

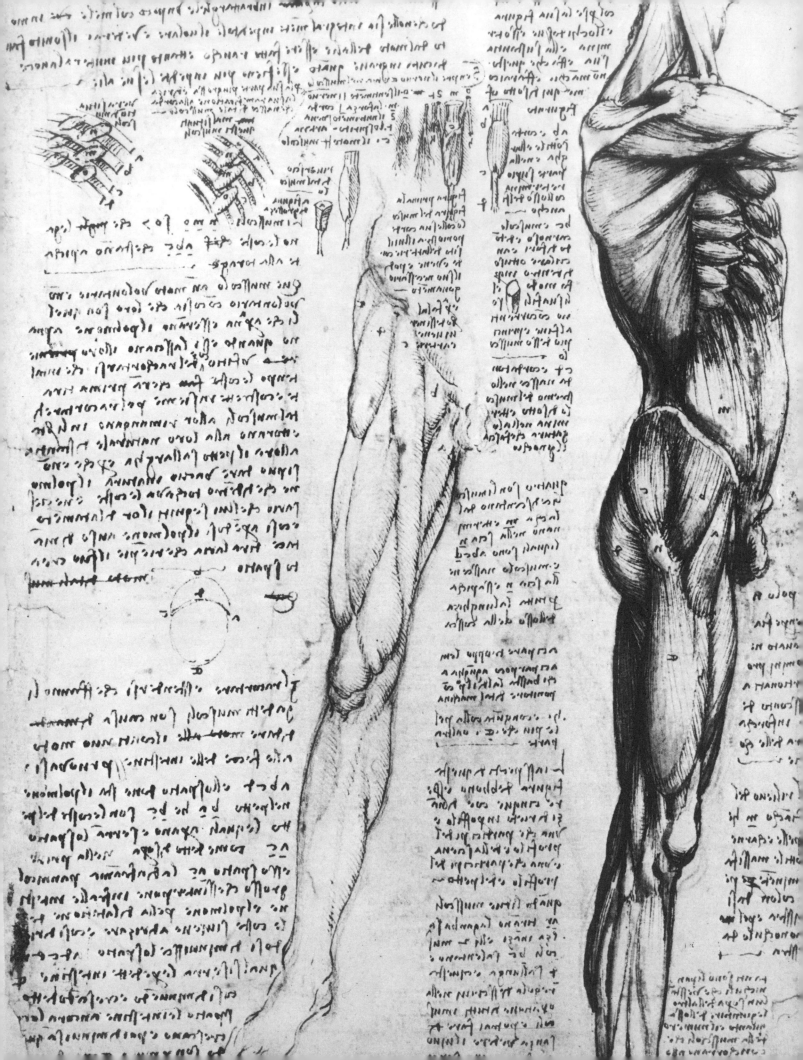

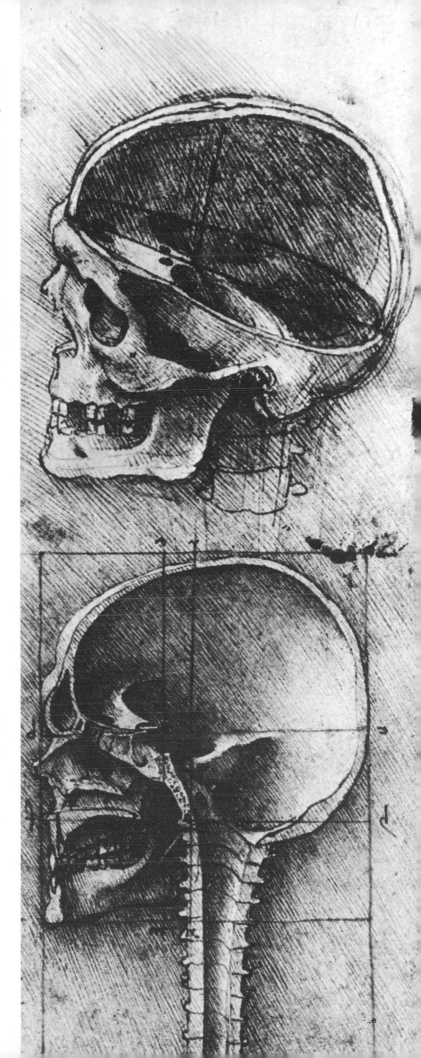

90. OPPOSITE *Sketches of muscles: c. 1509–10*

In the centre, the superficial muscles of a man's right thigh and knee; at the right, the superficial muscles of a man's shoulder, trunk and leg, including, in the thorax, the digitation of the serratus anterior muscle. Top left, small detail sketches of muscles, nerves and vascular supply.

Although Leonardo drew on the anatomical and physiological knowledge transmitted by Hippocrates, Galen and Arab physicians, especially Avicenna, he carried out his own researches and experiments, which resulted in extensive writings and in a long series of drawings. It was not only the shape and structure of the body, but primarily the functions of organisms and muscles, that captivated his interest – the heart and the circulation of the blood, the lungs and respiration. His researches were facilitated by the fact that at one time he had lodgings in the hospital of Santa Maria Nuova in Florence, where corpses were apparently placed at his disposal for dissection.

As was the case with so many other subjects, Leonardo planned to write a textbook on anatomy, dealing with the growth and developments of the human body from the foetus to the full-grown man, with the proportions and movements of the figure and with the construction and function of the sense-organs – a comprehensive work, foreshadowing that of Vesalius half a century later.

91. RIGHT *Two skulls: c. 1489*

The upper drawing shows a horizontal section of the cranium with the left wall removed, the sinuses, the cavity in the upper jawbone, and the eye-socket. The lower drawing shows a vertical section through the centre and the ten uppermost vertebrae of the spinal column. But these are drawn purely schematically, without distinction between the seven vertebrae of the neck and the first three of the thorax. Moreover, the spinous processes (thornlike protrusions) at the back are erroneously repeated at the front and this suggests that the vertebrae have been drawn from memory.

The upper inscription begins: 'Where the line *am* intersects the line *cb* will be the confluence of the senses.' This refers to the ancient notion that, in Leonardo's words, 'human judgement is produced by an organ to which the other five senses transmit the sensations [which they receive from outside], and this organ they have named Common Sense ['sensus communis']. And they say that this Sense is located in the centre of the head between Sensation and Memory.' In the drawing Leonardo's lines intersect just above the pituitary fossa, a position corresponding approximately to the third ventricle of the brain.

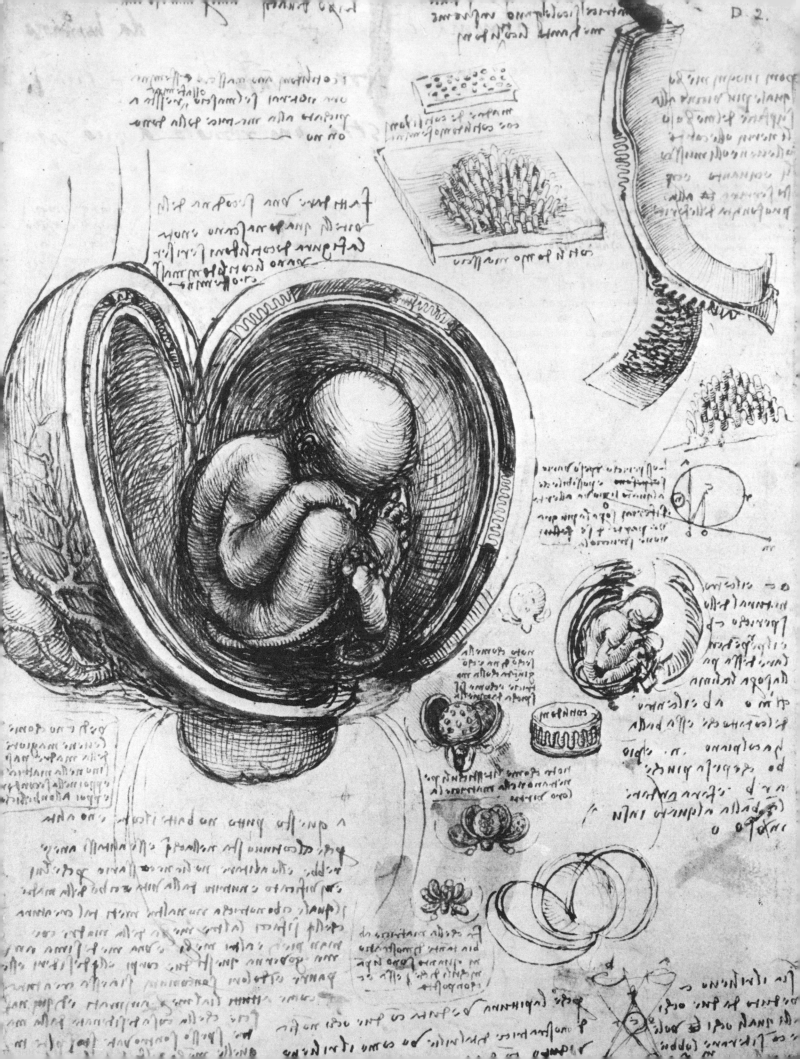

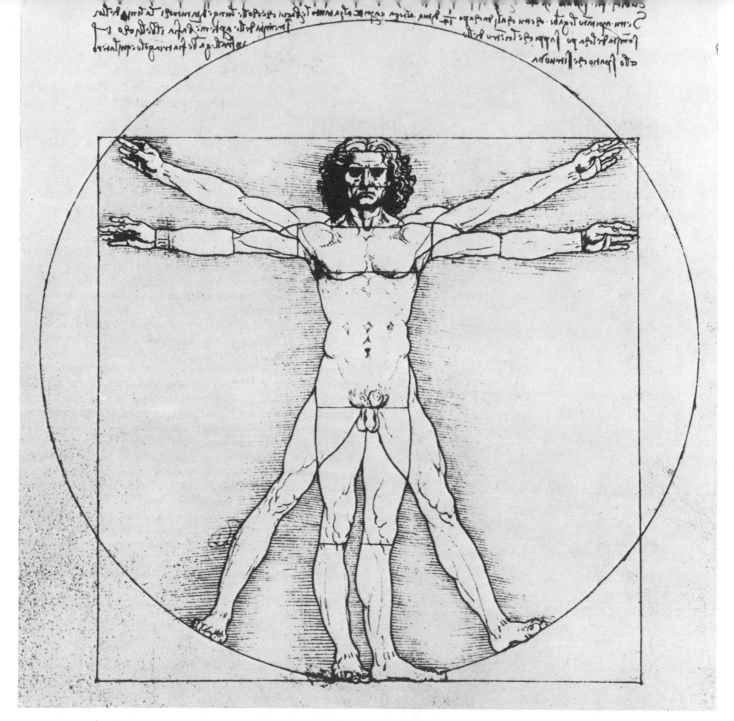

92. OPPOSITE *An embryo in the uterus and other sketches*: c. *1510–12*

The large drawing shows a fully developed foetus inside a human uterus, but with a cow's placenta. The four drawings top right are details of the cotyledonary placenta of a hoofed animal (Leonardo apparently knew nothing of the human, disc-shaped placenta). Below, centre right, an unrelated drawing of an excentrically weighted sphere on an inclined plane. Below this, on the left a minute sketch of a uterus with an indication of the cotyledons, and at the right a rough sketch of the foetus in the uterus with successive coverings. Next, side by side, a uterus opened to show membranes and placenta, and at the right, interdigitating cotyledons. Further below, three sketches of the uterus and foetal membranes laid open, the upper sketch showing also the embryo within its amnion (the innermost membrane). Lastly, an unrelated diagram of binocular vision.

93. ABOVE *The Vitruvian canon of human proportions*: c. *1490*

The drawing illustrates a passage in the famous book of the Roman architect Vitruvius: 'The navel is naturally placed in the centre of the human body, and if a circle is described round a man lying with his face upwards and his hands and feet extended, it will touch his fingers and his toes. It is not only by a circle that the human body can be thus circumscribed, as may be seen by placing it within a square. For if we measure from the feet to the crown of the head, and then across the arms fully extended, we shall find the latter measure equal to the former, so that the lines at right angles to each other enclosing the figure would form a square.'

Leonardo is known to have planned, and believed to have made, an anatomical model of a man for use in connection with his paintings and sculpture, and perhaps for the instruction of pupils. In some of his studies of proportions (such as the present), the measurements are based on the canon handed down by Vitruvius, with the face being the tenth part of a man's total height.

94. *Sketch of a hand*

Leonardo wrote and drew with his left hand, possibly as a result of an injury to his right hand during childhood. This sketch of his own hand at work appears on a page in the *Codex Atlanticus* covered with unrelated jottings.

95. CENTRE LEFT *Partial view of a town:* c. *1487–90*

This is one of several sketches for the layout of a new town with a double system of high-level and low-level roadways. Leonardo may have been entrusted by the Sforza to design an urban centre near their residence at Vigevano, south-west of Milan.

The inscription reads: 'The roads *m* [high-level, left and right] are six *braccia* higher than the roads *ps* [foreground, right to left] and each road must be twenty *braccia* wide and have half a *braccio* slope from the sides towards the middle; and in the middle, at every *braccio*, there will be an opening, one *braccio* long and one finger wide, where the rain-water may run off into hollows made on the same level as *ps*. And on each side of the road there will be an arcade, six *braccia* broad, on columns; and he who wants to cross the whole place by the upper streets can use them for this purpose, and he who wants to go by the lower can equally do so. On the upper streets no vehicles and similar objects must circulate, but they are exclusively for gentlemen [ie pedestrians]. Carts and burdens for the use and convenience of the inhabitants have to go by the lower streets. The houses must be back to back, with the lower street running between them. Provisions such as wood, wine and suchlike are carried in by the doors *n*, and privies, stables and other fetid matter must be emptied away underground ... and at each arch there must be a spiral staircase, because the corners of square ones are always fouled, and at the first vault there must be a door to the public privies. The stairs lead from the upper to the lower streets, and the high-level streets begin outside the city gates and slope up until they reach a height of six *braccia*.'

One Milanese *braccio* equalled 59·5 cm. (23⅜ in.)

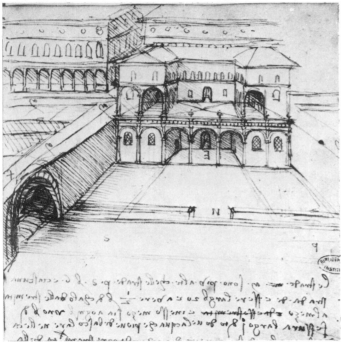

96. LEFT *Plan for streets and canals:* c. *1487–90*

In this town, as planned by Leonardo, the cellars of the houses are made accessible to boats. The drawing shows merely the ingenious principle he had in mind; a fuller explanation is given in the accompanying notes, which read in part: 'The front *am* will give light to the rooms ... *cdf* is the place where the boats come to the house to be unloaded. In order to make this arrangement practicable the cellars must not be exposed to flooding from a swollen river and it is necessary to choose a suitable site, such as a spot near a river which can be diverted into canals in which the water level will not be affected by flooding or drought. The construction is shown below; and choose a fine river, which the rains do not render muddy ... The device that keeps the waters at a constant level will be a lock and basin as shown below, situated at the entrance of the town or, better still, some way within, in order that the enemy may not destroy it ... One needs a fast-flowing river, which will not contaminate the air of the town and which is also convenient for cleansing the town frequently once the lock below the town is raised, and with rakes and hooks one can remove the mud which will accumulate at the bottom of the canals and will make the water turbid. And this must be done once a year.'

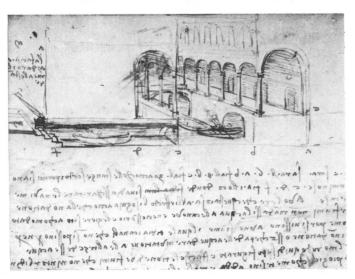

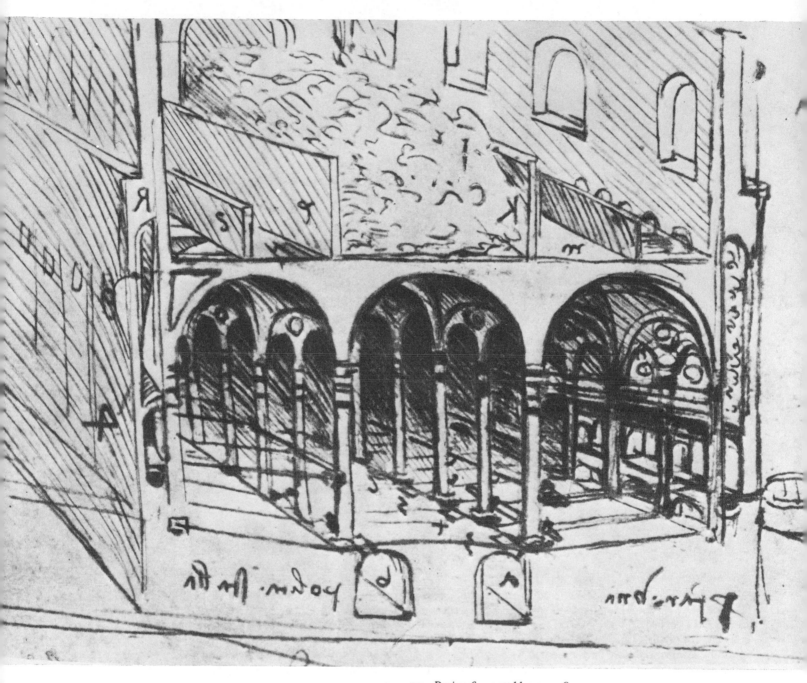

97. *Design for a stable:* c. *1487–90*

Leonardo's down-to-earth mind and the attention he paid even to the smallest detail is shown in the accompanying inscription, which reads, in part, as follows: 'As for the watering of the horses, the troughs should be of stone and above them [cisterns of] water, so that the mangers can be opened, like boxes, by raising their lids . . . As for the stale, you place a wedge-shaped stone at the hind feet of the horses . . . and you could do without straw if you make the beds of oak or walnut boards. And when the horses want to stale [urinate] they move back so that the stale falls where their hind feet are. And when the lids are lifted the dung can be collected and thrown through holes into vaults . . . and from the caves it is carried to a place where it is not a nuisance.'

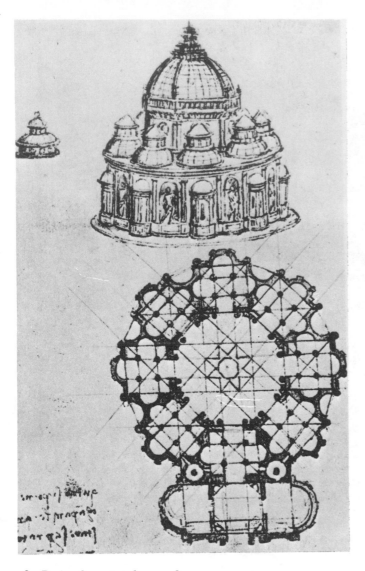

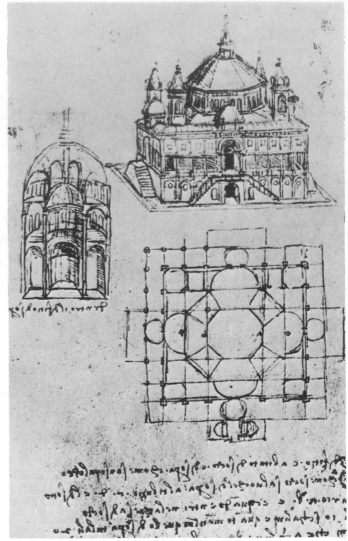

98. *Design for a church: c. 1487–90*

When Leonardo began his architectural studies, the style of Filippo Brunelleschi was still the inspiration of Florence, and several of Leonardo's studies reveal the influence of the cupola and lantern of the cathedral of Santa Maria del Fiore. But no building is known to have been executed by Leonardo. Most of his plans for ecclesiastical architecture were theoretical and ideal researches into the laws which must govern the construction of a great central dome with smaller ones grouped around it. To produce the grandest effect, a large dome crowning a building had to rise either from the centre of a Greek cross (a cross with four equal arms) or from the centre of a structure whose plan has some symmetrical affinity to a circle, this circle being the centre of the whole plan.

In the design on this sheet the dome rises from an octagonal base. The central octagon is expanded by a square chapel on each of its eight sides. The chapels themselves are square with three apses and, in the centre, four pillars supporting a cupola. Of particular interest is the use of an expanding eight-pointed star in the central octagon of the ground-plan. In conformity with the ground-plan, the exterior is richly articulated with an unusual alternation of niches and apses, the former containing gigantic statues. At the top left is a small sketch of a 'tiburio', a tower over a crossing.

99. *Designs for a church: c. 1487–90*

Like most of Leonardo's ground-plans for churches, this plan is based on the shape of a Greek cross (a cross with four equal arms). It is comprised of a square building, which in turn is surrounded by a portico on all four sides. The exterior view shows, in addition, that the upper storey was to be made accessible from the outside by two ramps of steps on each side. The drawing on the left shows, according to the inscription, a section of the same building, but seems difficult to reconcile with the plan. The design may have been suggested by the church of San Lorenzo in Milan.

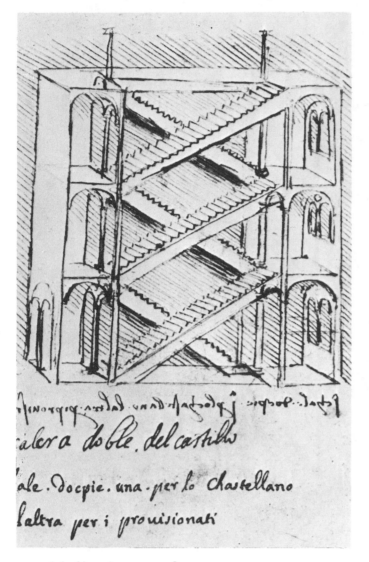

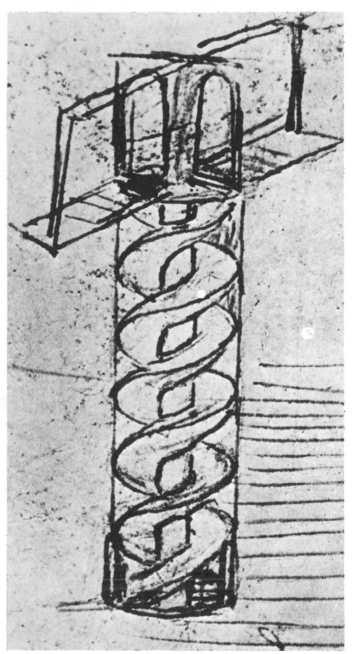

100. *A double staircase: c. 1487–90*

The inscription reads: 'Double staircase, one for the commandant of the castle, the other for the garrison.' This shows that the drawing was made in connection with the designs for military architecture, to which Leonardo devoted a great deal of attention, as he did also to gunnery, to the theory of ballistics and to other aspects of warfare. He planned numerous improvements in the construction of bridges and fortifications – towers, ramparts, ravelins, bastions, casemates, trenches, palisades, etc. – in the provisioning of armies, in the design of cannon, siege-machines and other ingenious devices.

101. *A double-spiral staircase: c. 1487–90*

Leonardo explains the military purpose of such designs in his notebook: 'He who intends to capture a tower standing on the seashore will contrive to get one of his followers hired by the commandant of the castle, and when it is the turn of that man to mount guard he will throw the rope ladder, given him by the enemy, over the merlons, thus enabling the soldiers to swarm over the walls. And in order to make this impossible I divide the tower into eight spiral staircases and into eight defensive positions and quarters for the garrison, so that, if one is disloyal, the others cannot join him. And each defensive position will be so small that it allows room for no more than four men. The commandant, who lives above, can beat them back, firing through the machicolations and locking them up behind the iron grating, and place smoke devices at the head of the spiral staircases. And on no account may a foreign soldier stay with him, but only his immediate entourage.'

102. *A system of staircases:* c. *1487–90*

This exterior view looks at first sight like a modern fire-escape, but only because the walls have been omitted from the front and the left side in order to demonstrate the architectural principle. The staircases were of course intended to be built inside, as is shown by the walls and windows at the left and back and even more clearly in the ground-plan. Leonardo explains the purpose of this design in his inscription: 'Here are five staircases with five entrances, and one is not visible to another, and he who is on one cannot enter another. It is a good thing if the [soldiers of a] garrison cannot mix with each other and if they are [kept] separate for the defence of the tower. And it can be [built whether the tower is] round or square.'

BIBLIOGRAPHY

Baldacci, A., *Le Piante di Leonardo da Vinci, in Memorie della R. Accademia di Scienze*, Bologna, 1914–16, 1922–3, 1935–9

Booker, P. J., *A History of Engineering Drawing*, Chatto and Windus 1963

Clark, K., *The drawings of Leonardo da Vinci at Windsor Castle*, 3 vols, Phaidon 1969

de Toni, G. B., *Le Piante e gli Animali in Leonardo da Vinci*, Bologna 1922

de Toni, W., *L'idraulica in Leonardo da Vinci*, Brescia 1934–5

Esche, S., *Leonardo da Vinci, das anatomische Werk*, Basle 1954

Firpo, L., *Leonardo architetto e urbanista*, Turin 1963

Gibbs-Smith, C. H., *Leonardo da Vinci's Aeronautics*, H.M.S.O. 1967

Goldscheider, L., *Leonardo da Vinci, Landscapes and Plants*, London 1952

Gombrich, E. H., 'The Form of Movement in Water and Air', in *The Heritage of Apelles*, Phaidon 1976 [This article was first published in O'Malley, C. D., ed., *Leonardo's Legacy*, 1969]

Hart, I. B., *The World of Leonardo da Vinci*, Macdonald 1961

Heydenreich, L., *Leonardo da Vinci*, Cresset Press 1957

McCurdy, E., *The Notebooks of Leonardo da Vinci*, 2 vols, London 1939, reprinted 1956

Needham, J., *Science and Civilisation in China, IV*, Cambridge 1965

O'Malley, C. D., and de C. M. Saunders, J. B., *Leonardo da Vinci on the human body*, New York 1952

O'Malley, C. D., ed., *Leonardo's Legacy, An International Symposium*, University of California 1969

Parsons, W. B., *Engineers and Engineering in the Renaissance*, M.I.T. Press 1968

Pedretti, C., *The Literary Works of Leonardo da Vinci: A commentary*, 2 vols, Phaidon 1977

Reti, L., ed., *The Unknown Leonardo*, Hutchinson 1974

Reti, L., and Dibner, B., *Leonardo da Vinci, Technologist*, Burndy Library, Connecticut 1969

Reti, L., *The Madrid Codices, Transcription and Translation*, McGraw Hill 1974

Richter, J. P., *The Literary Works of Leonardo da Vinci . . .*, 2 vols, London 1970

Ritchie Calder, *Leonardo and the Age of the Eye*, Heinemann 1970

Singer, C. et al, *A History of Technology*, Clarendon Press 1956

Usher, A. P., *A History of Mechanical Inventions*, Harvard University Press 1954

CHRONOLOGY

1452 15 April: Leonardo born near Vinci, in Tuscany, the illegitimate son of Ser Piero da Vinci and Caterina

1453 The fall of Constantinople ends the Eastern Empire

1469 Leonardo enters workshop of Andrea Verrocchio. Giuliano and Lorenzo de Medici inherit leadership of Florence

1472 Leonardo admitted to the Guild of St Luke as a painter

1473 Nicholas Copernicus, the astronomer, born in Poland

1475 Michelangelo born at Caprese in Tuscany

1476 Leonardo remains in Verrocchio's studio as an assistant

1478 The Pazzi conspiracy to overthrow the Medici in Florence. War with Naples and the Pope follows

1479 Leonardo now living independently

1481 Leonardo offers his services in a letter to Ludovico Sforza, ruler of Milan

1482 Moves to Milan as painter and engineer to Ludovico Sforza

1483 Contract (25 April) for *The Virgin of the Rocks*, now in the Louvre. Raphael born at Urbino

1485 Leonardo studies total eclipse of the sun

1487 Anatomical studies

1490 Works on stage design for the pageant *Il Paradiso* by Bernardo Ballincioni

1492 Visits Rome
 Columbus's first voyage to the New World. Lorenzo the Magnificent dies. Rodrigo Borgia elected Pope and takes the name Alexander VI

1494 Charles VIII of France invades Italy. The Medici expelled from Florence

1495 Leonardo starts work on the *Last Supper*

1498 Ludovico Sforza gives Leonardo a vineyard in recognition of his services as painter and engineer

1499 The French invade Italy and capture Milan. Leonardo flees Milan

1500 February: Leonardo visits Mantua; March: goes to Venice; by 24 April in Florence. Ludovico Sforza captured by French and held in France

1501 Leonardo works on *The Madonna and Child with St Anne*. Amerigo Vespucci makes second voyage to the New World, the published account of which led to America being named after him

1502 Leonardo employed as military engineer to Cesare Borgia on his campaign in Central Italy

1503 *The Battle of Anghiari* commissioned

1505 Leonardo studies flights of birds

1506 Invited to Milan by Charles d'Amboise, the French governor of the city. Building the new basilica of St Peter's in Rome starts

1507 Returns to Florence

1508 Back in Milan for anatomical and other research

1511 Anatomical research with Antonio de la Torre. Milan at war with Venice and the Pope (Julius II)

1512 Restoration of the Medici in Florence. Michelangelo completes Sistine ceiling. The French lose Milan

1513 Leonardo works for Giuliano de Medici in Rome

1515 The French recapture Milan

1516–17 Leonardo moves to France, and lives in the Manor of Cloux near Amboise

1519 2 May: Leonardo dies at Cloux and is buried in the Church of St Florentin in Amboise

SOURCES OF ILLUSTRATIONS

Cod Atl – *Codice Atlantico* (Ambrosiana Library, Milan)
MSS B, G and BN – Notebooks in the library of the Institut de France, Paris
Sul Volo – *Sul Volo degli Uccelli*, Royal Library, Turin
Windsor – Royal Library, Windsor Castle
Cod Arundel – Arundel manuscript, British Museum
Cod Leicester – Leicester manuscript, British Museum

LIST OF INVENTIONS

1. Prone ornithopter
2. Prone ornithopter
3. Prone ornithopter with head harness
4. Prone ornithopter with alternate leg action
5. Semi-prone ornithopter
6. Boat-shaped ornithopter
7. Boat-shaped ornithopter with crank and pulley transmission
8. Standing ornithopter
9. Undercarriage of standing ornithopter
10. Powered ornithopter
11. Semi-ornithopter with 'hang-glider' position
12. Falling-leaf glider
13. Flap-valves for ornithopters
14. Mechanism for flapping and twisting an ornithopter wing
15. Ornithopter pilot controlling flight by body movements
16. Ornithopter wing-testing rig
17. Parachute
18. Helicopter
19. Aircraft inclinometer
20. Armoured tank
21. Scythed cars
22. Rope ladders and scaling ladders
23. Defence against scaling ladders
24. Flying bridges
25. Catapult
26. Giant crossbow
27. Rapid-firing crossbow
28. Finned missile
29. Breech-loading cannon
30. Streamlined projectiles
31. Foundry courtyard
32. Pocket battleship
33. Field-cannon
34. Machine-gun
35. Mortar
36. Steam-cannon
37. Tackle
38. Rope-making machine
39. Lifting jack
40. Vertical drilling machine
41. Horizontal drilling machine
42. Treadle lathe
43. Rolling-mill
44. Machine for drawing cannon-staves
45. Twin cranes
46. Printing press
47. Travelling crane
48. Automatic release mechanism
49. Postmills and horizontal windmills
50. Roller- and ball-bearings
51. Chain drive
52. Chain-links
53. Water turbine
54. Variable-speed gearing
55. Air turbine
56. Reciprocating to rotary motion
57. Gimbal-ring suspension
58. Four-vaned and two-vaned fly
59. Clock spring equalizer
60. Calorimeter
61. Airscrew-operated smoke-jack
62. Archimedean screws for raising water
63. Well pumps, waterwheels and Archimedean screws
64. Elements of machines
65. Treadmill-powered digging machine
66. Canal with locks and weirs
67. Floating dredger
68. Harbour dredger
69. Ships' hulls
70. Water floats
71. Diving suit
72. Snorkel
73. Life preserver
74. Double-hulled and semi-submersible boats
75. Paddle boat
76. Crank-operated paddle boat
77. Treadle-powered boat